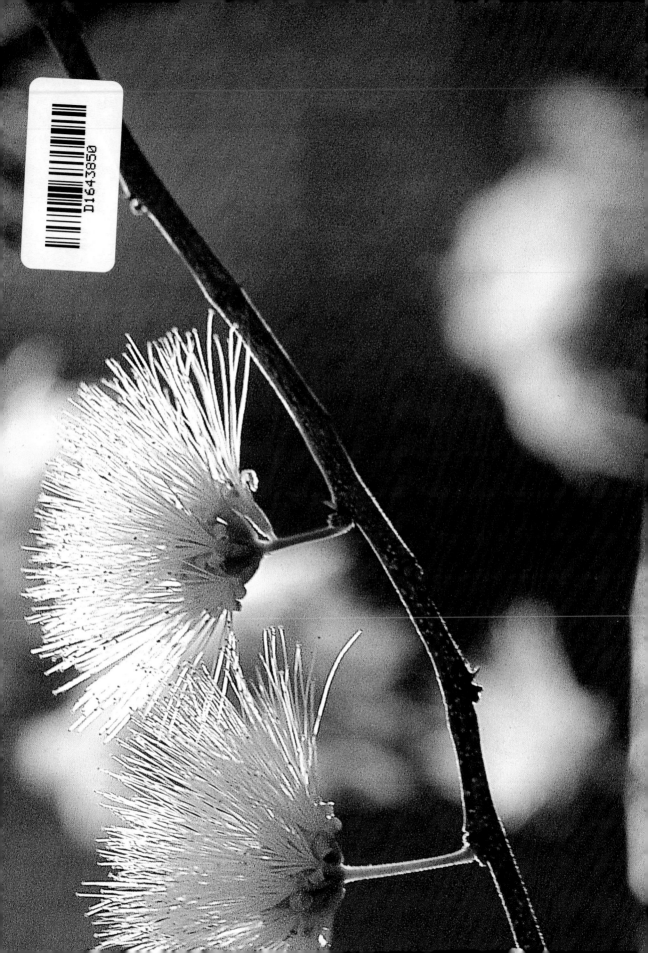

KRUGER

A VISUAL SOUVENIR

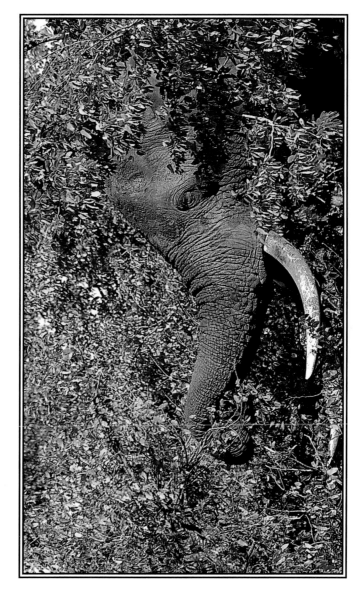

NIGEL DENNIS

Struik Publishers
(a division of New Holland Publishing
(South Africa) (Pty) Ltd)
Cornelis Struik House, 80 McKenzie Street
Cape Town 8001

New Holland Publishing is a member of
the Johnnic Publishing Group.
www.struik.co.za
Log on to our photographic website
www.imagesofafrica.co.za for an
African experience.

First published in 1998.
3 5 7 9 10 8 6 4

ISBN 1 86872 108 6

Copyright in published edition:
Struik Publishers (Pty) Ltd 1998
Copyright in text: Nigel Dennis 1998
Copyright in photographs: Nigel Dennis 1998

Editor: Jenny Barrett
Designer: Dominic Robson
Text: Nigel Dennis

Reproduction: Hirt and Carter, Cape Town
Printing: Times Offset (M) Sdn Bhd

TITLE PAGE An elephant feeds in the dense
mopane of the Shingwedzi region.
RIGHT The Kruger National Park supports
good numbers of leopard but it is not easy to see
this secretive animal – early morning and late
afternoon game drives offer the best chance.

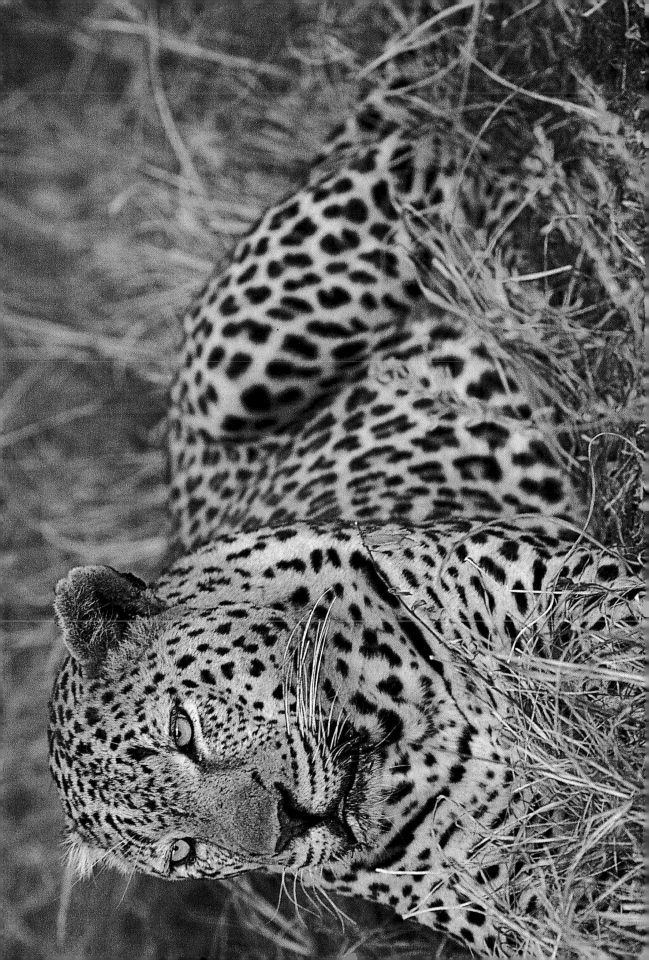

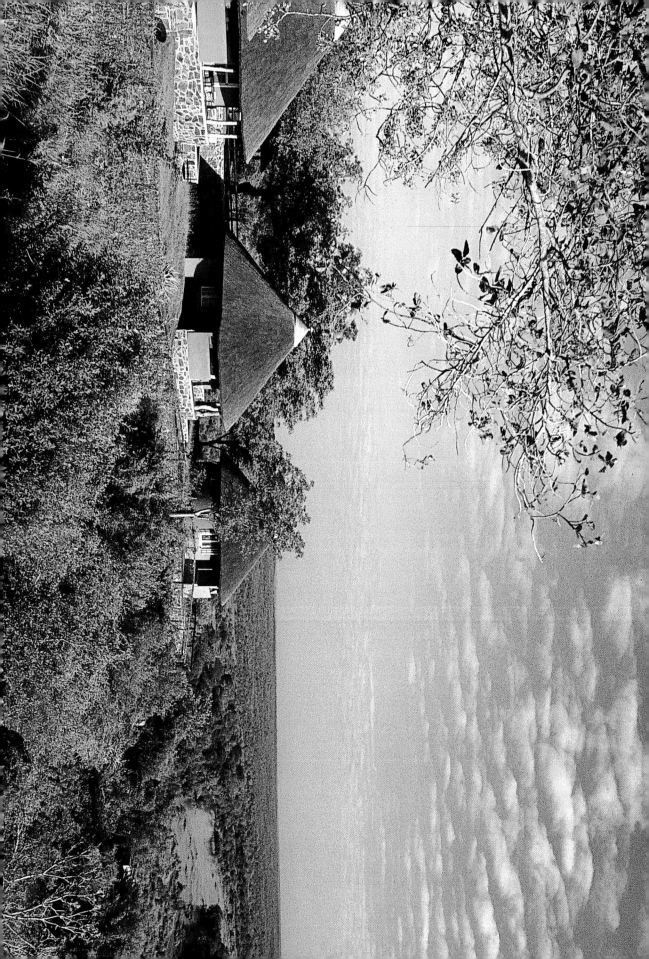

INTRODUCTION

Sprawled across the Lowveld of South Africa's far northeastern corner, the 20 000-square-kilometre Kruger National Park is undoubtedly the region's most famous – and most visited – wildlife sanctuary. Although its best-known inhabitants and biggest drawcard are the 'Big Five' – lion, leopard, elephant, rhinoceros and buffalo – more than half of southern Africa's 900 birds and 280 mammal species are represented here, and the Park is also home to a wide diversity of insects, reptiles and plant life. Kruger offers spectacular game-viewing opportunities across a variety of habitats, from waterholes and rivers to open plains, mopaneveld and forest, each offering the visitor something different to admire and enjoy.

LEFT The Olifants Rest Camp offers superb views of the river valley and surrounding veld.

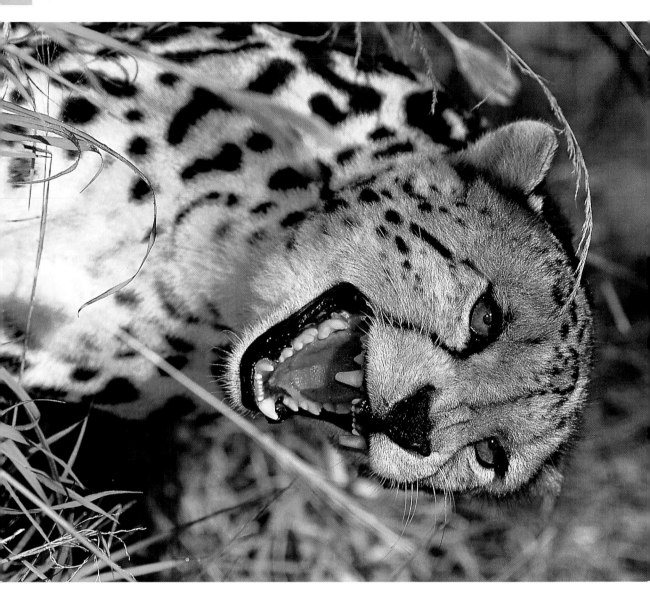

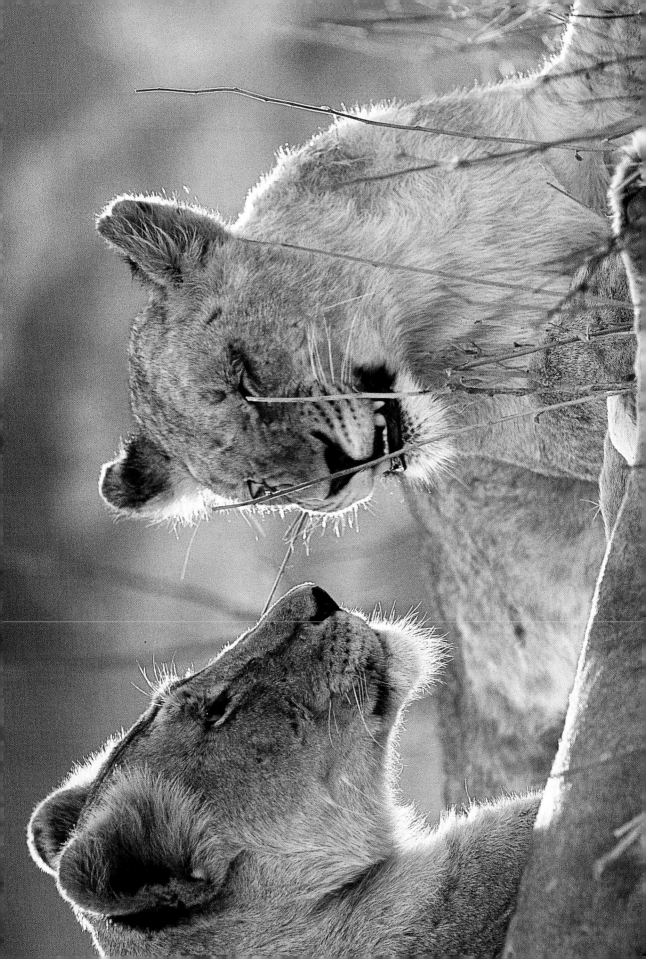

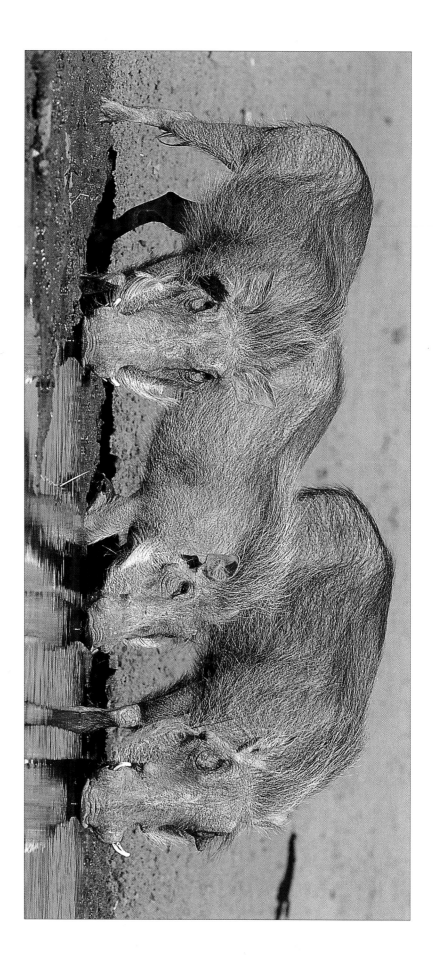

PREVIOUS PAGES, LEFT The king cheetah is a rare form of the ordinary cheetah whose spots on the upperparts and flanks merge into stripes.

PREVIOUS PAGES, RIGHT A lioness and her subadult cub relax during the heat of the afternoon.

ABOVE Temporary pans form throughout the Park after good rains. Warthog use these pans as both drinking places and mud wallows.

OPPOSITE One of the best places to see white rhino is in the Bergendal area, where this mother and calf were photographed.

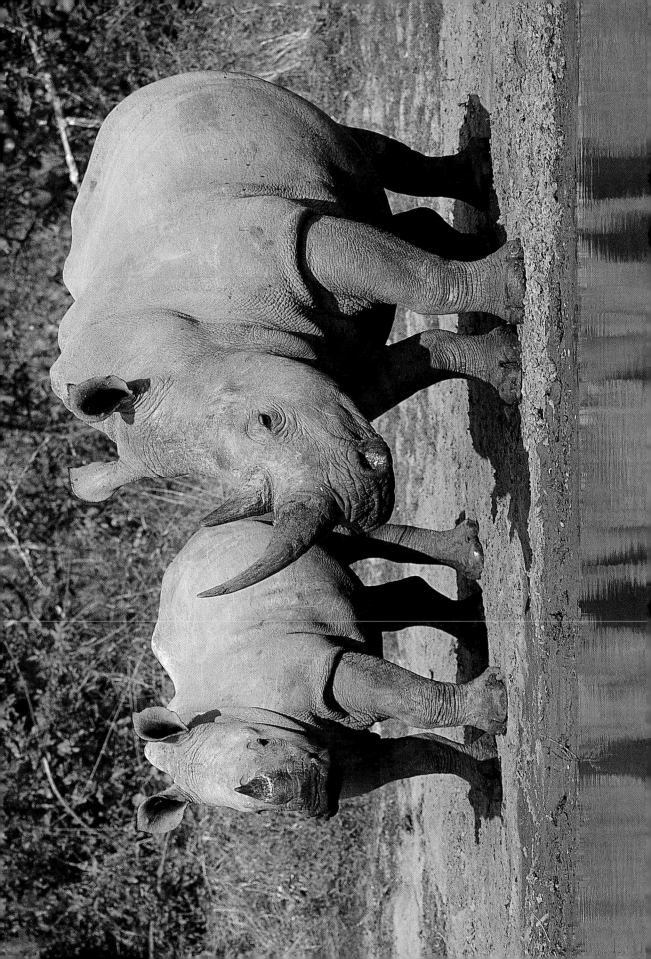

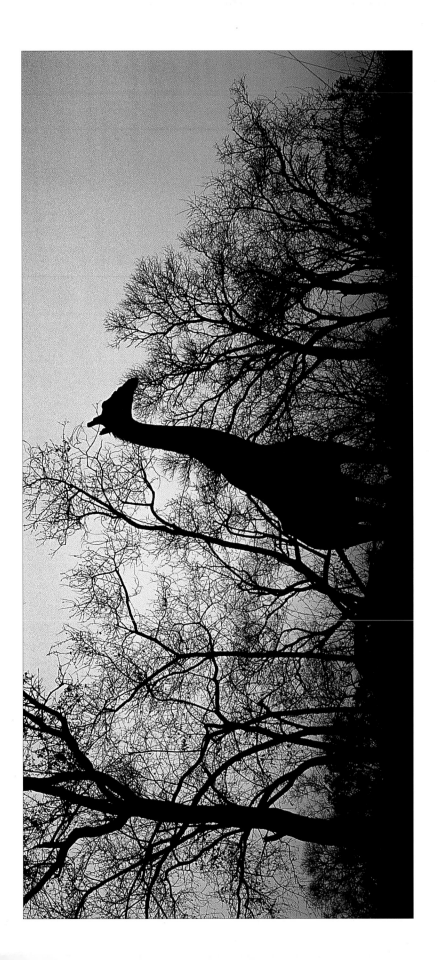

OPPOSITE A weak winter sun rises over the fertile plains near Tshokwane – a prime wintering area for big herds of zebra and wildebeest.

ABOVE Despite its size, the giraffe is not necessarily safe from hunting lion as darkness approaches.

OVERLEAF With temperatures approaching 40 °C, a buffalo herd approaches a nearby waterhole in some haste.

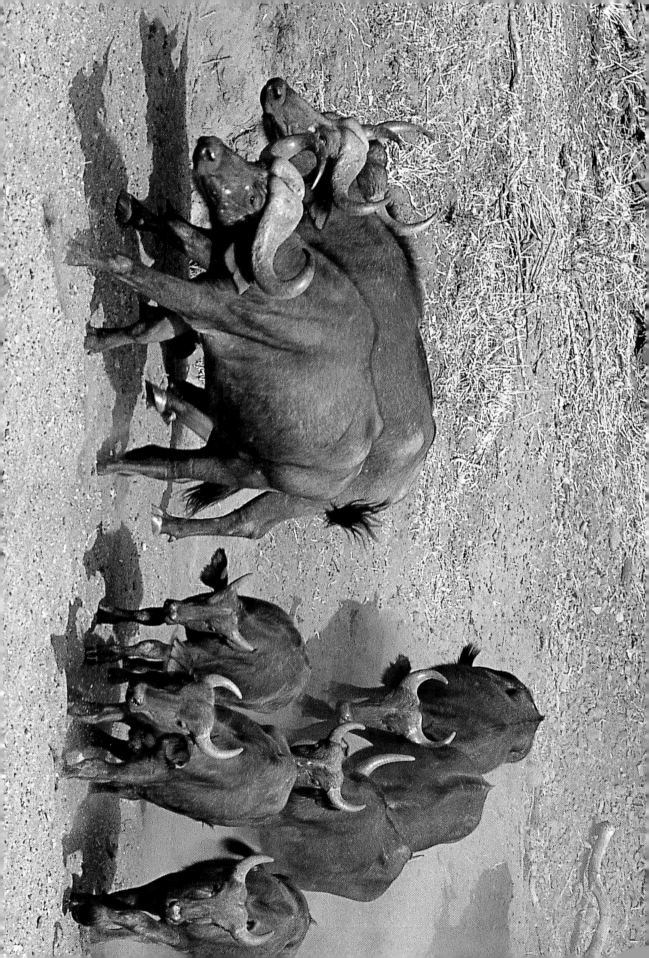

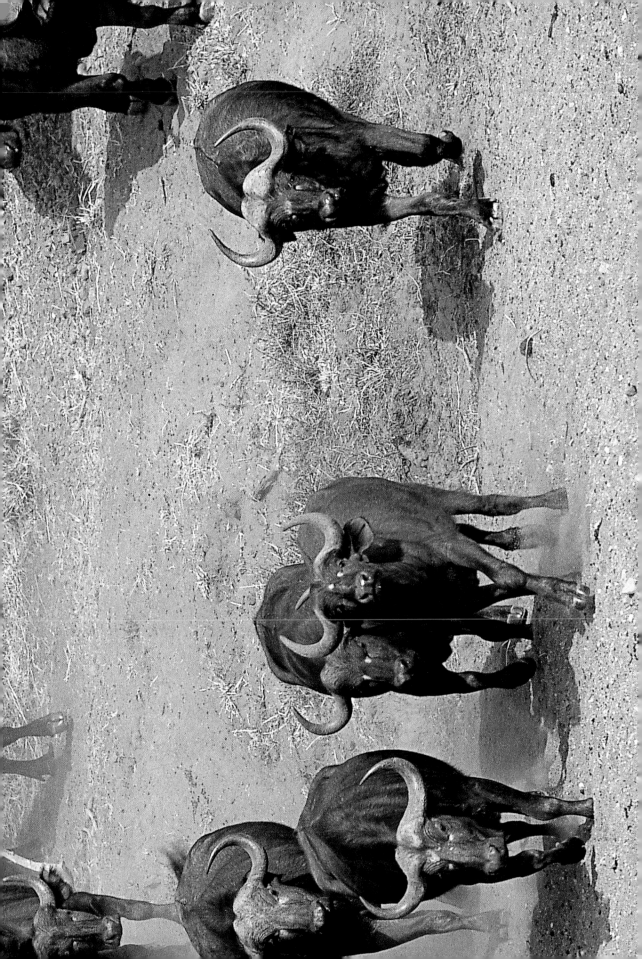

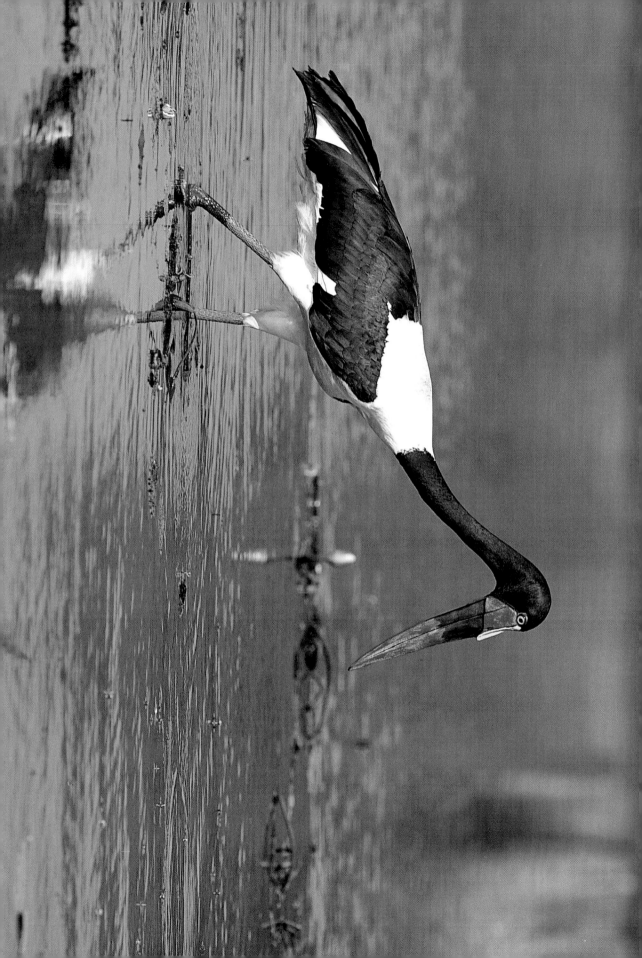

Although both are classed as endangered species in South Africa, saddlebilled storks (OPPOSITE) and yellowbilled storks (LEFT) can often be seen in the Kruger National Park.

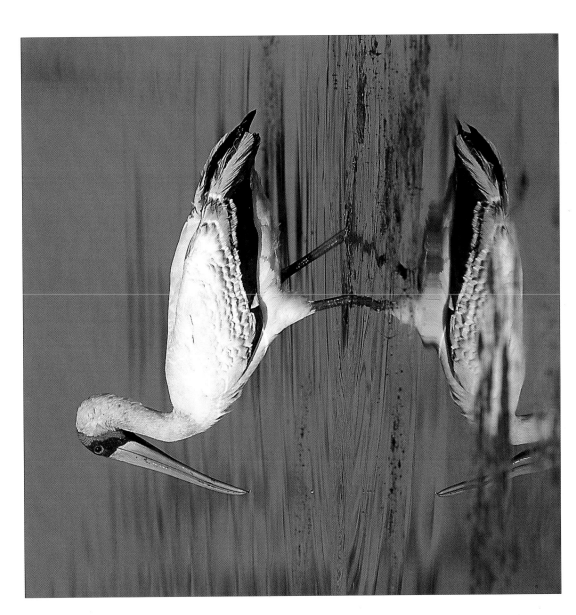

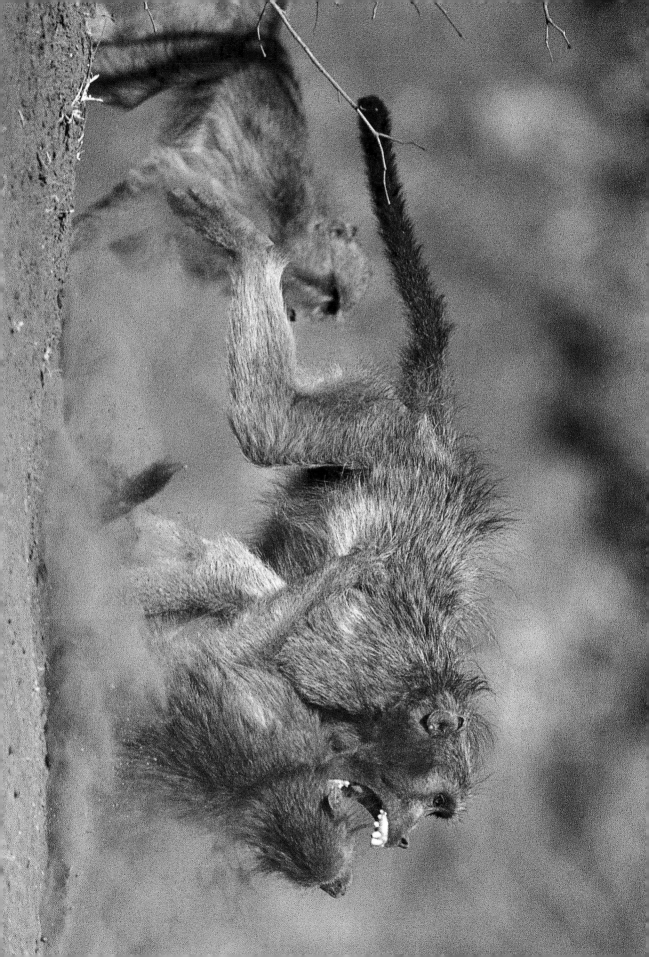

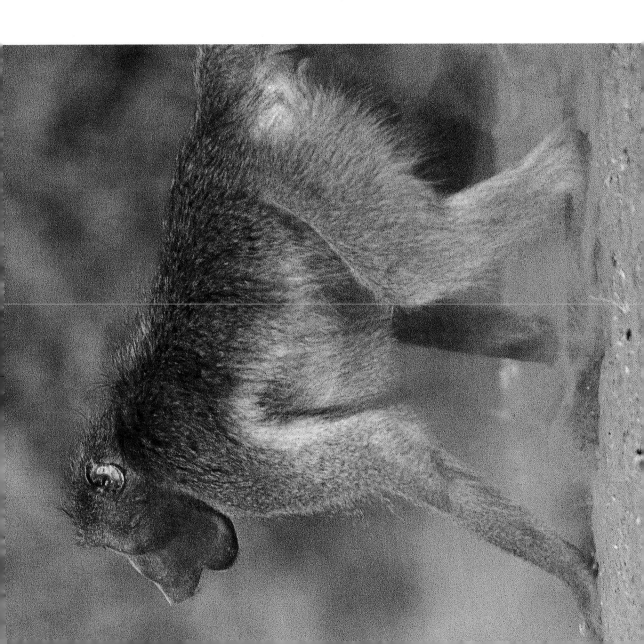

LEFT Visitors to the Park often pass them by, but chacma baboon troops can offer fascinating viewing opportunities – such as the display of aggression shown here.

OVERLEAF, LEFT A young crocodile and an immature African jacana share the shallow waters of Rooibosrand Dam near Bateleur Bush Camp.

OVERLEAF, RIGHT All of Kruger's main water bodies harbour Nile crocodiles, and the Sabie River, in particular, is host to some especially large specimens.

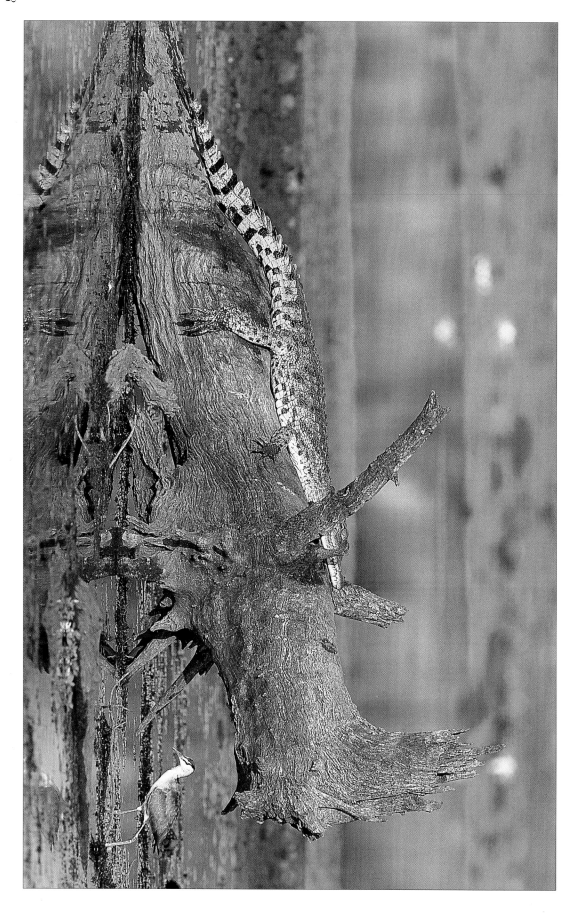

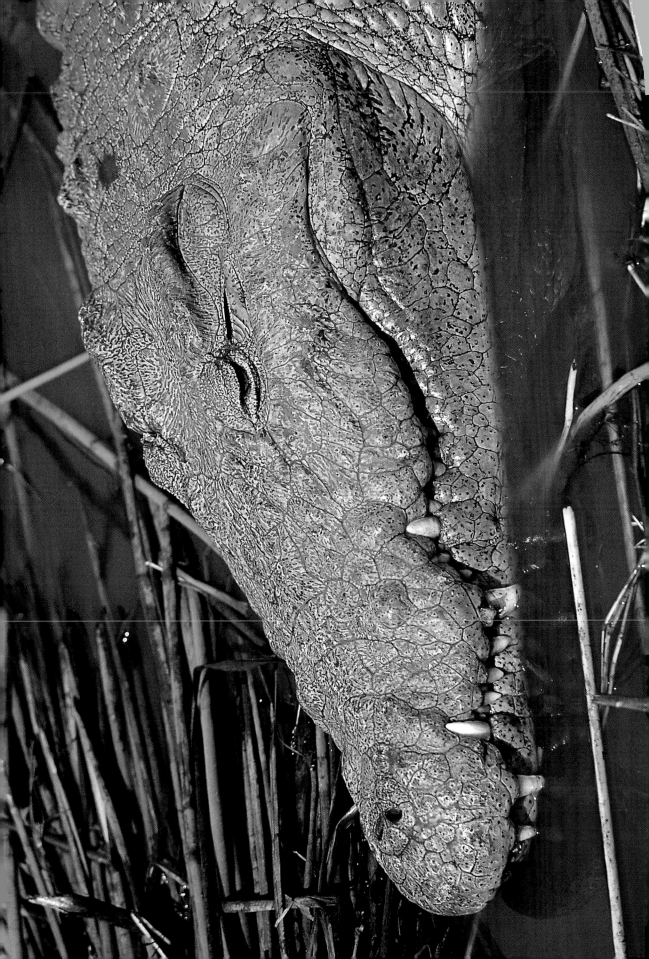

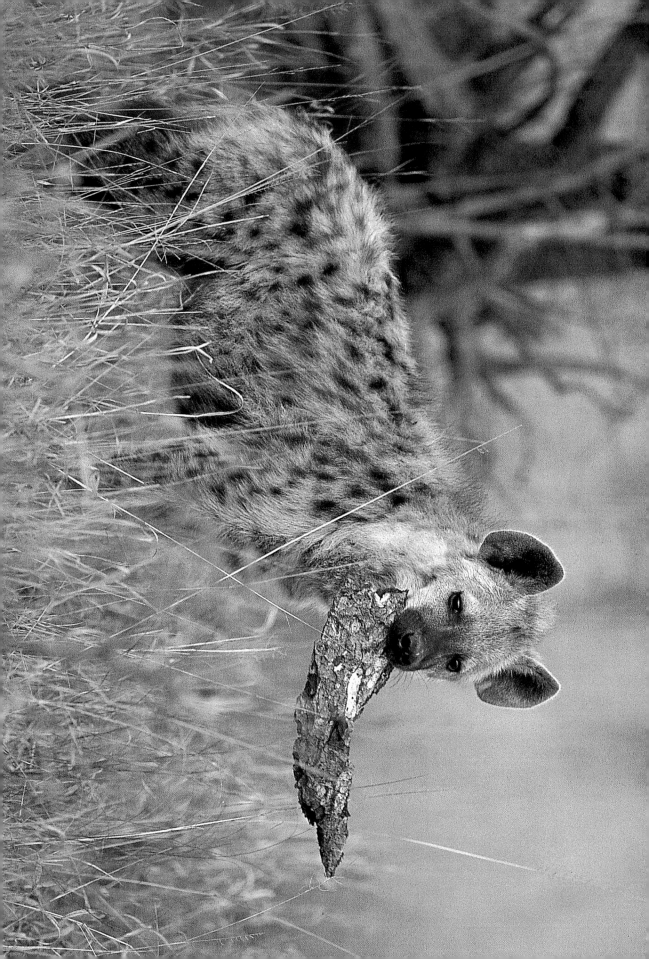

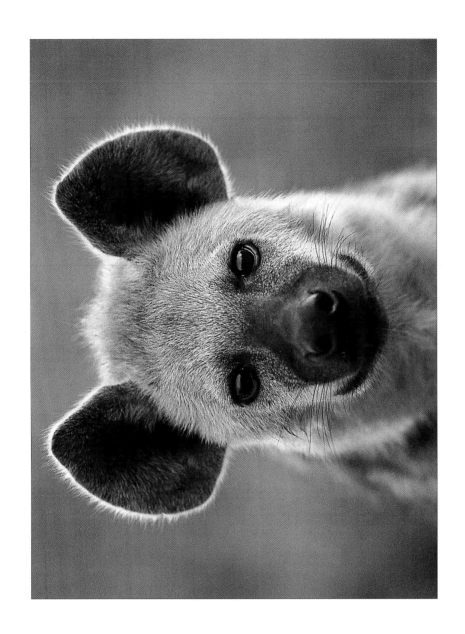

ABOVE In many parts of the Kruger National Park spotted hyaena den in roadside culverts and so become used to passing traffic.

LEFT A young spotted hyaena practises its hunting skills on a piece of wood.

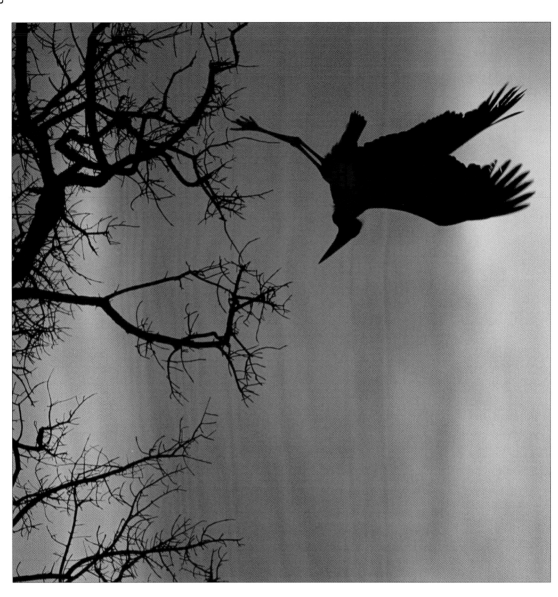

LEFT A marabou stork launches off into the sunset near Satara.

OPPOSITE Grey herons make use of a dead tree in Rooibosrand Dam as a safe nesting site.

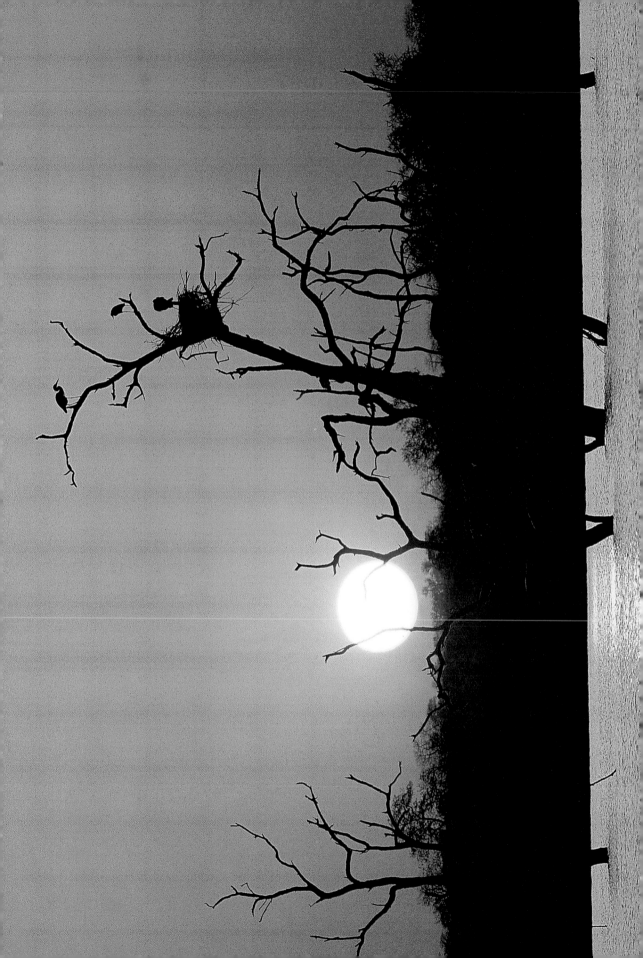

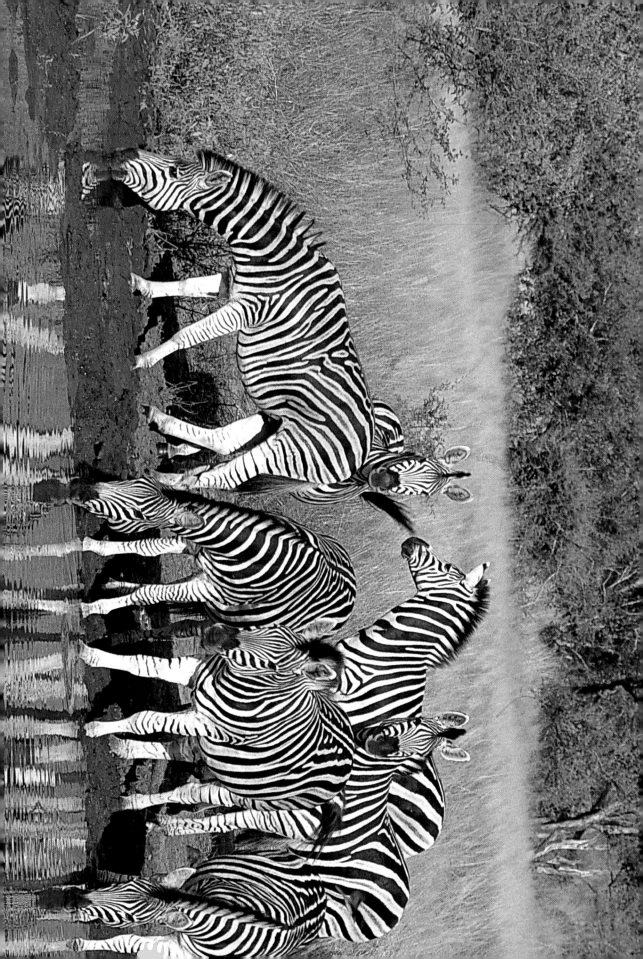

LEFT Mid-morning is a good time to stop at a waterhole and watch a variety of animals, such as these zebra, come down to drink.

OVERLEAF In just a couple of years this young male lion (LEFT) will resemble the magnificent specimen shown on the right.

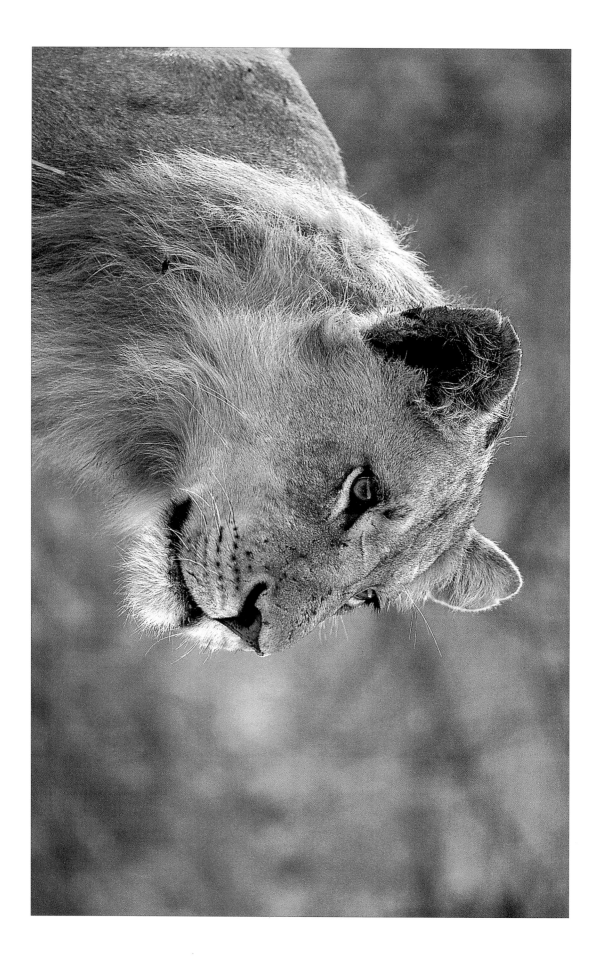

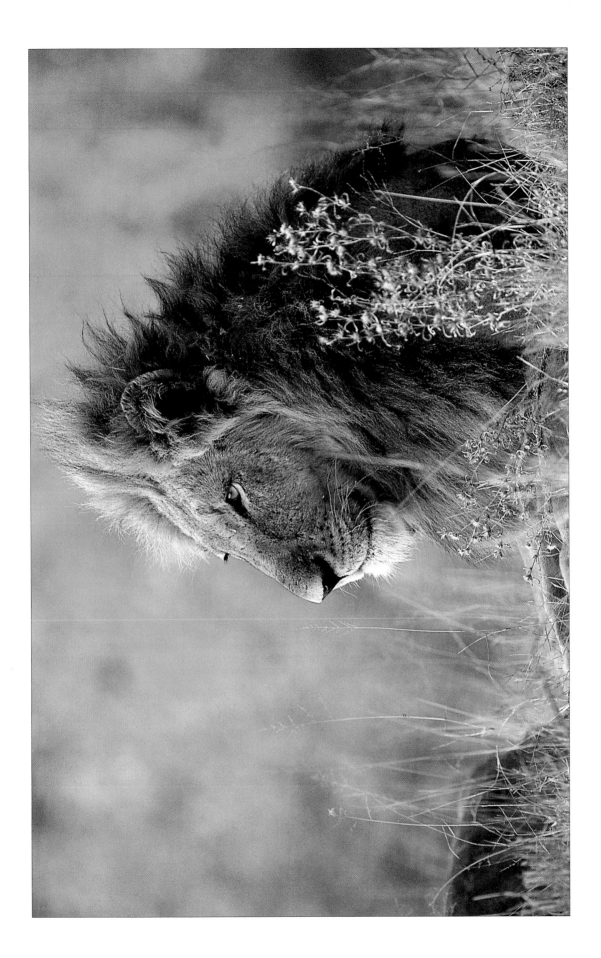

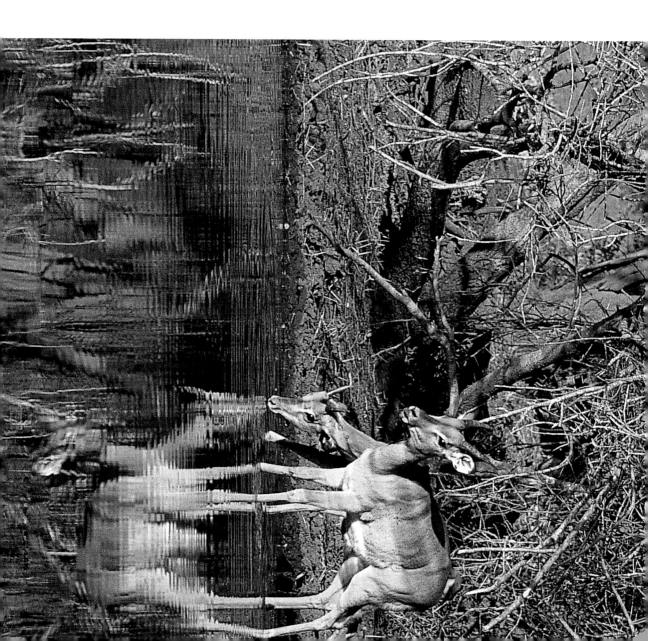

RIGHT *Impala remain alert to the danger of predators when drinking at a waterhole.*

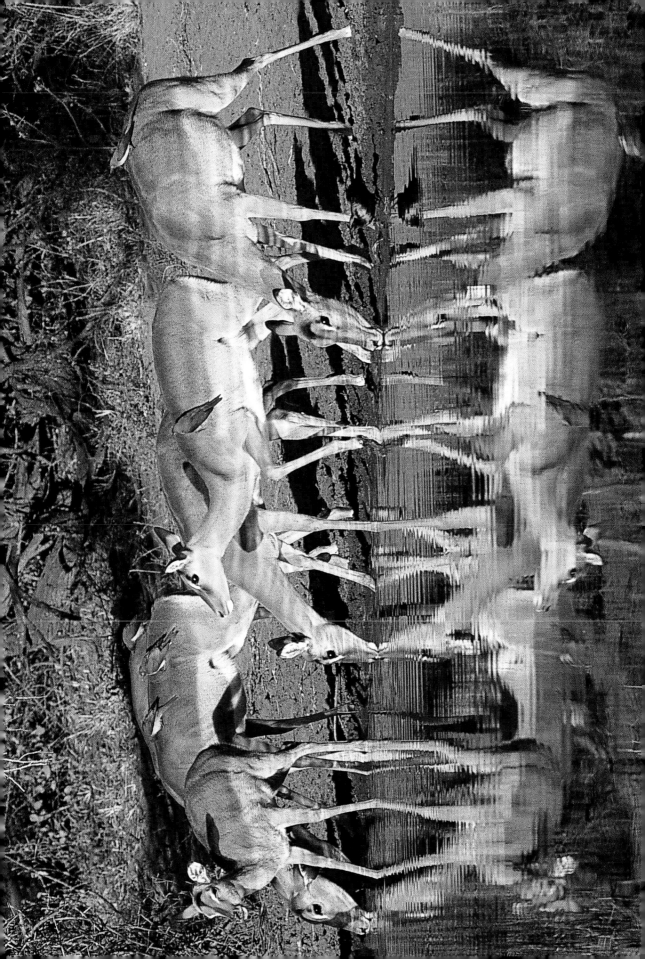

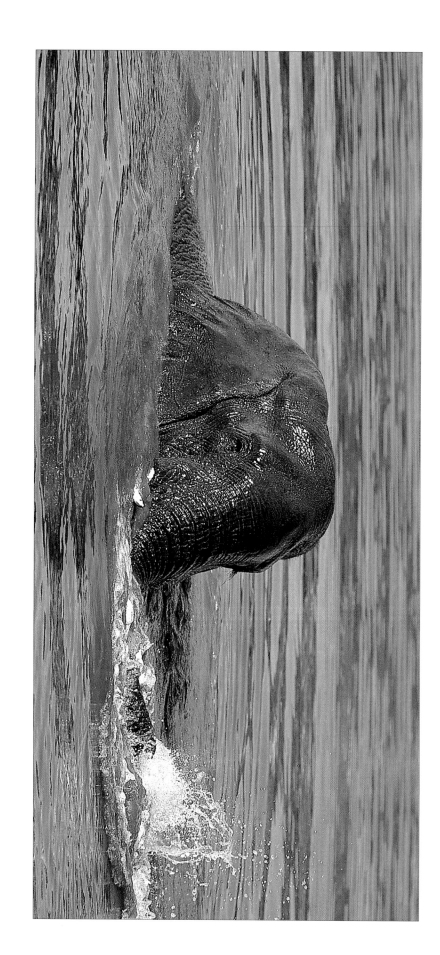

ABOVE An elephant finds welcome relief from the afternoon heat at Kanniedood Dam near Shingwedzi.

OPPOSITE Hippo in the Crocodile River at the Hippo Pools viewsite.

OVERLEAF, LEFT Sable antelope are most likely to be seen in the central parts of the Kruger National Park.

OVERLEAF, RIGHT A Kudu bull strolls through the veld on a misty morning.

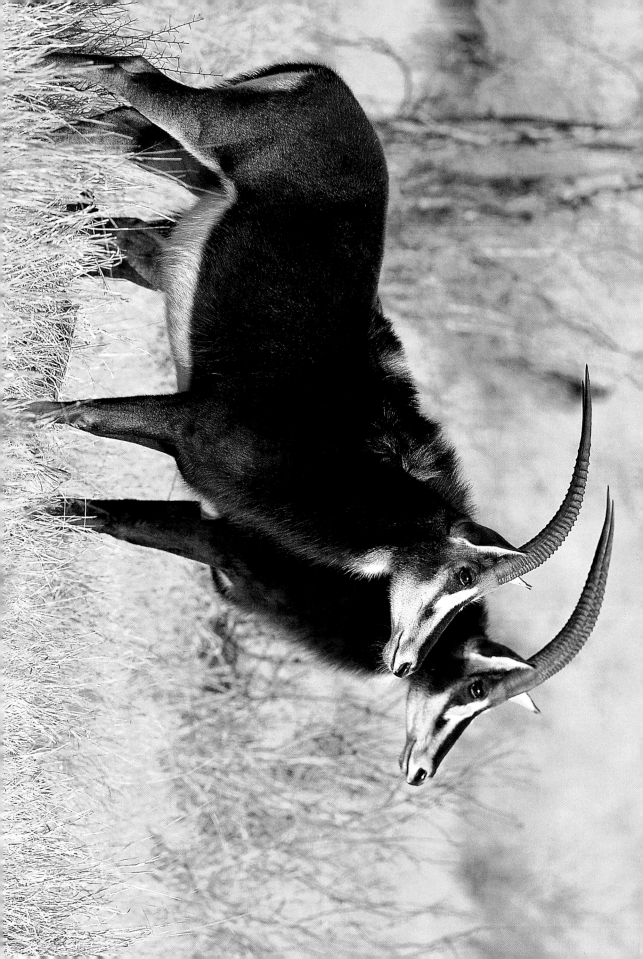

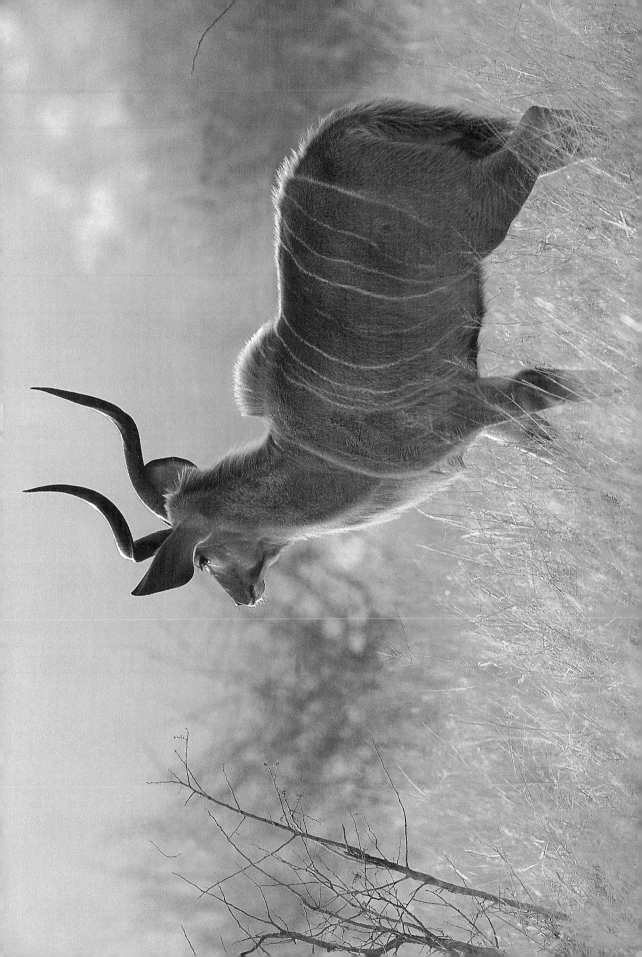

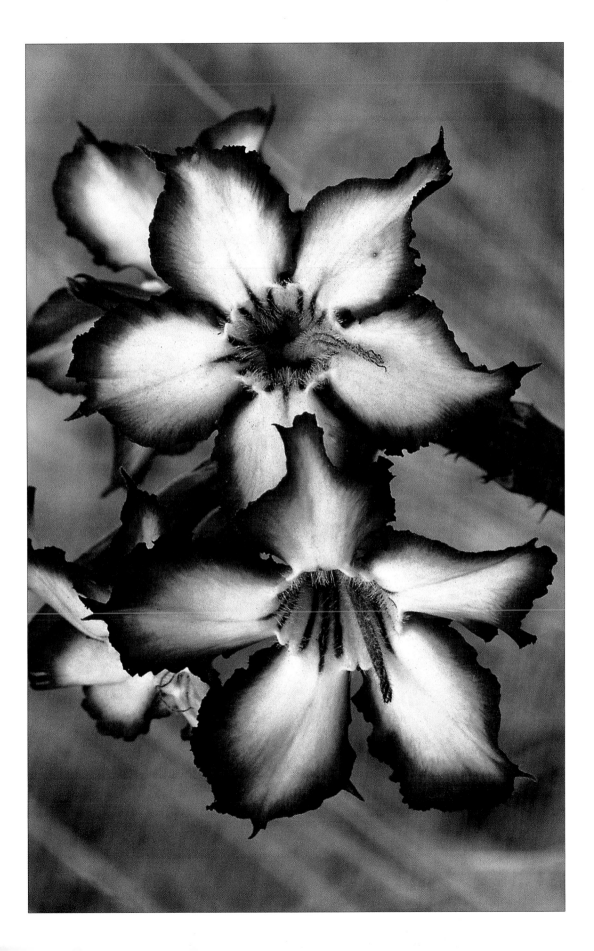

PREVIOUS PAGES, LEFT The blood lily comes into flower after the first rains of the season have fallen.

PREVIOUS PAGES, RIGHT The impala lily blooms in the winter months. Specimens can be found in several of the Park's rest camps.

RIGHT A rock monitor, or leguaan, emerges from its tree-hole home.

OPPOSITE Leopard tortoises tend to be most active following the first rains, when they may often be seen crossing the tourist roads.

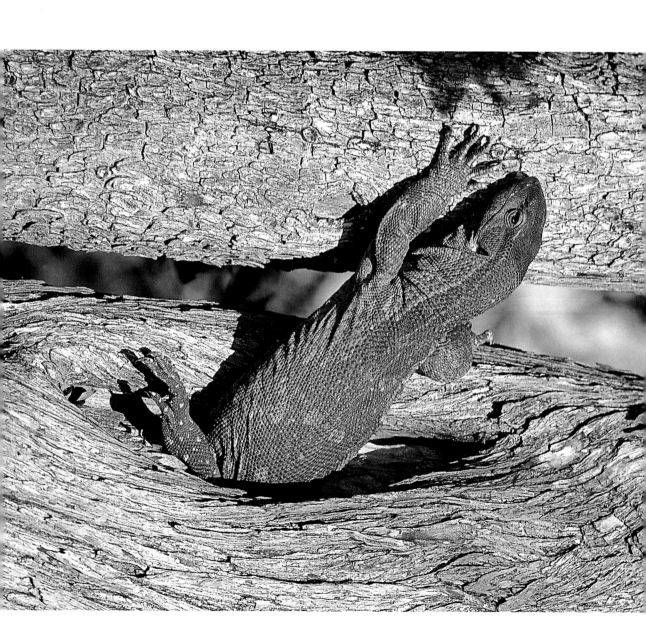

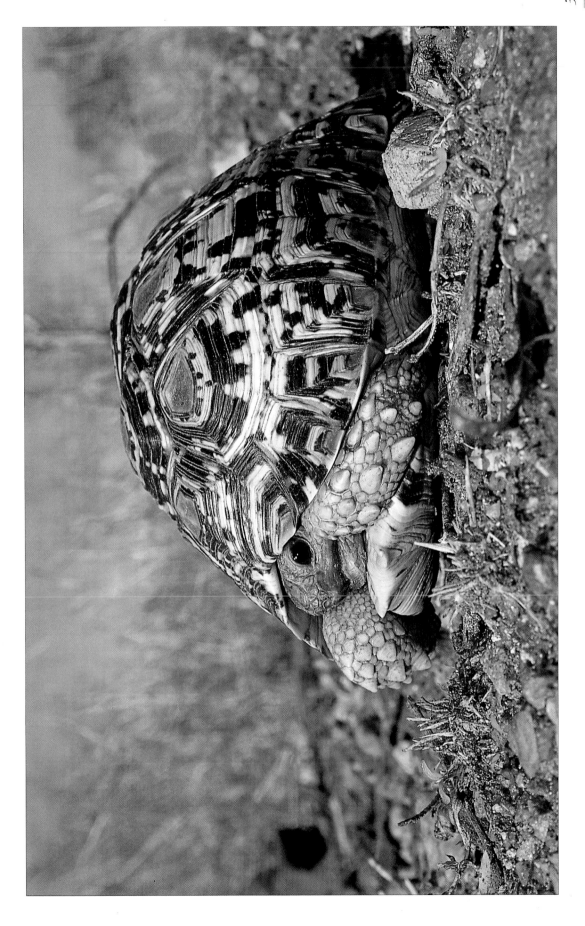

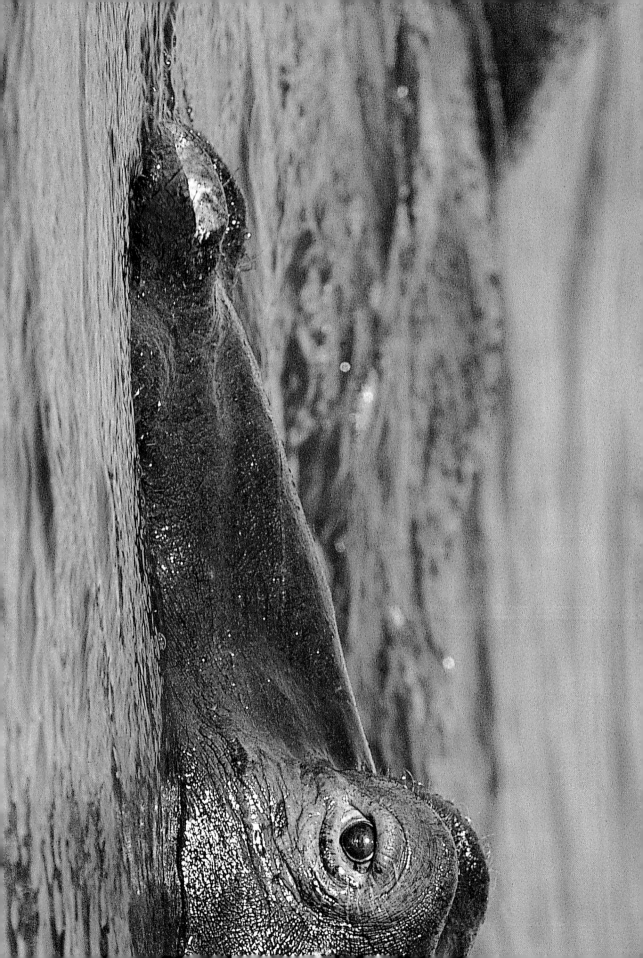

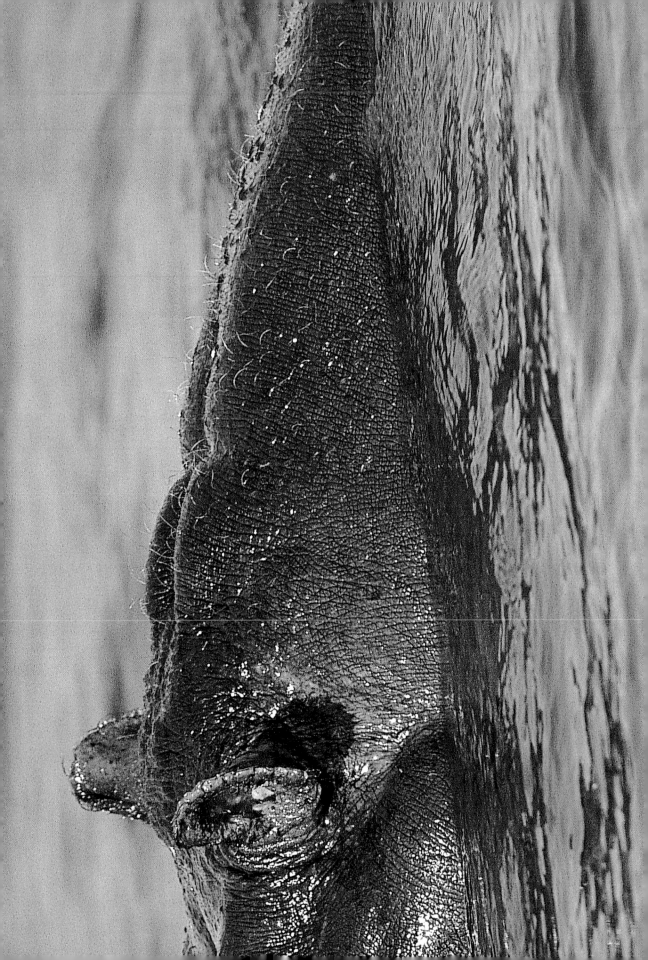

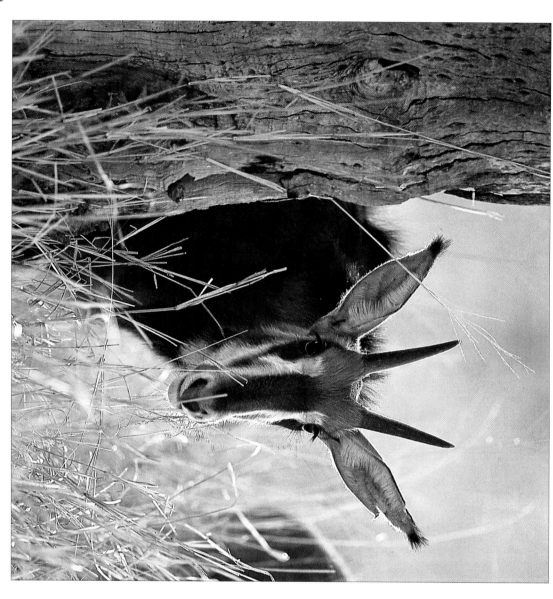

PREVIOUS PAGES Male hippo are fiercely territorial and will instinctively bite if startled or cornered.

LEFT A sable calf peers out from behind a tree.

OPPOSITE Flocks of redbilled oxpeckers often accompany buffalo herds, the parasites that live on the buffalo providing these little birds with a constant supply of food.

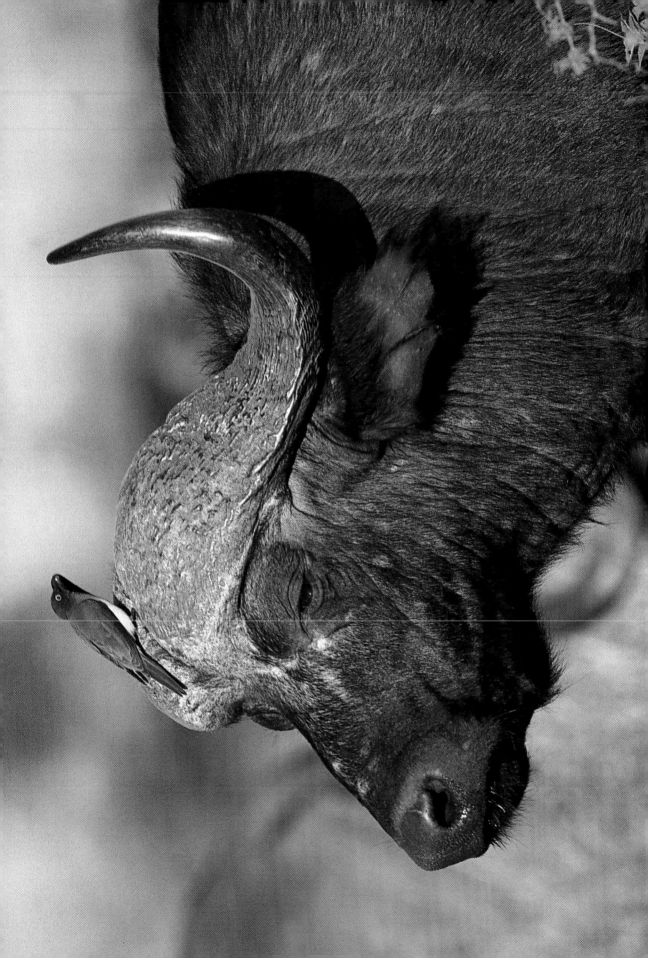

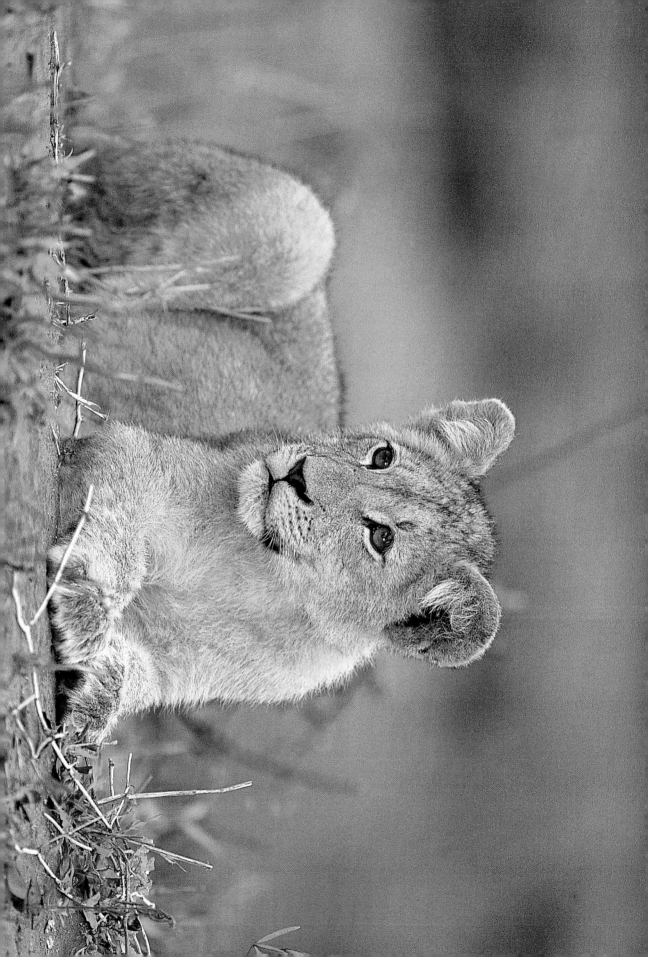

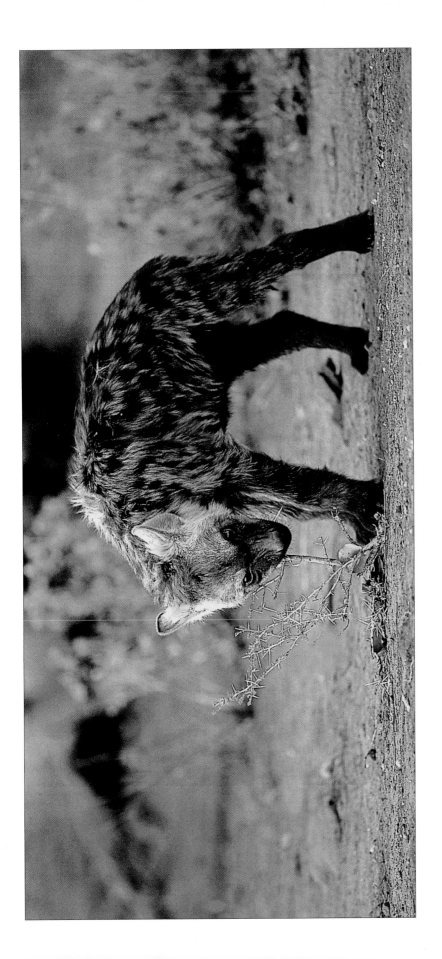

ABOVE *A young spotted hyaena pup tests its teeth on a twig. In the Kruger National Park these animals are both hunters and scavengers.*

OVERLEAF *The bateleur, once widespread in South Africa, now occurs only in the major conservation areas. It is frequently seen in Kruger.*

OPPOSITE *This male lion cub will stay with the pride until it is two or three years of age. By then it will have learnt to hunt for itself, and will be expelled from the pride by the dominant male.*

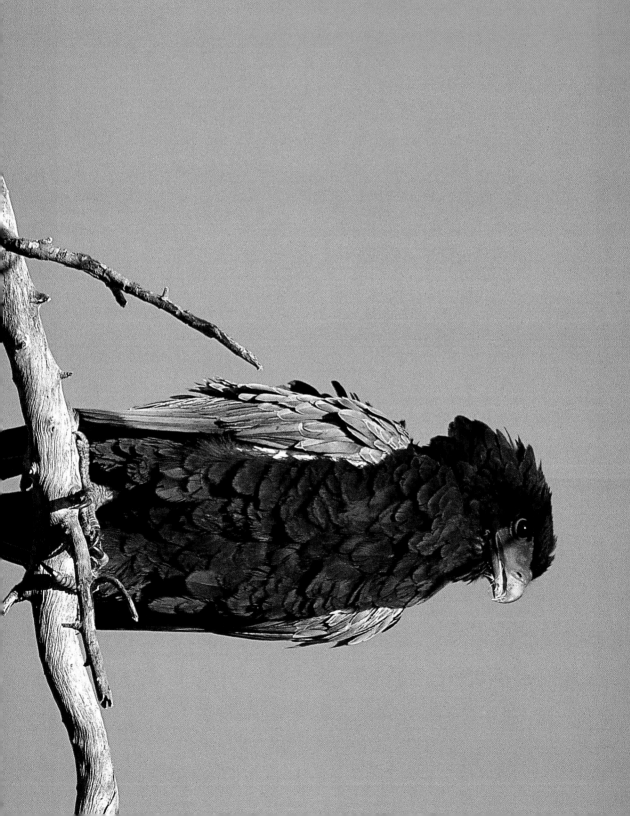

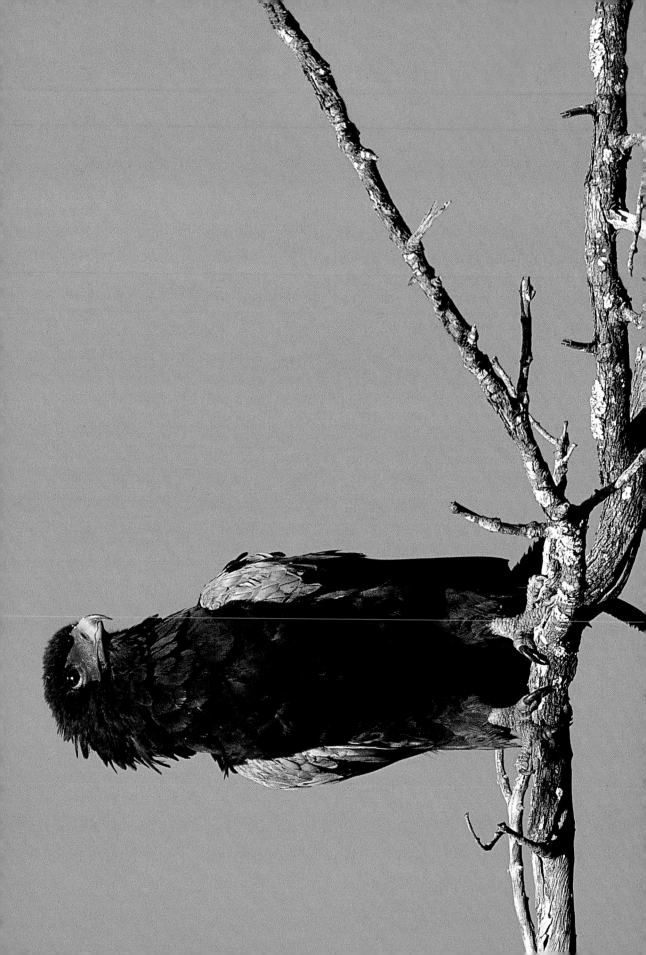

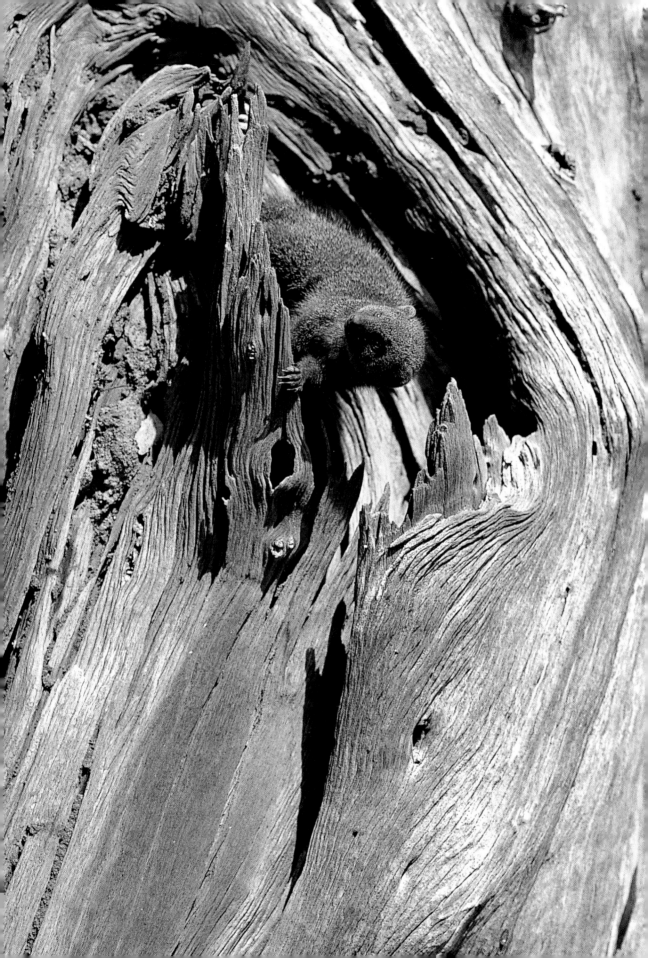

OPPOSITE A dwarf mongoose investigates a dead tree trunk for food such as beetle larvae and grubs.
LEFT Tree squirrels warm themselves in the early morning sunshine.

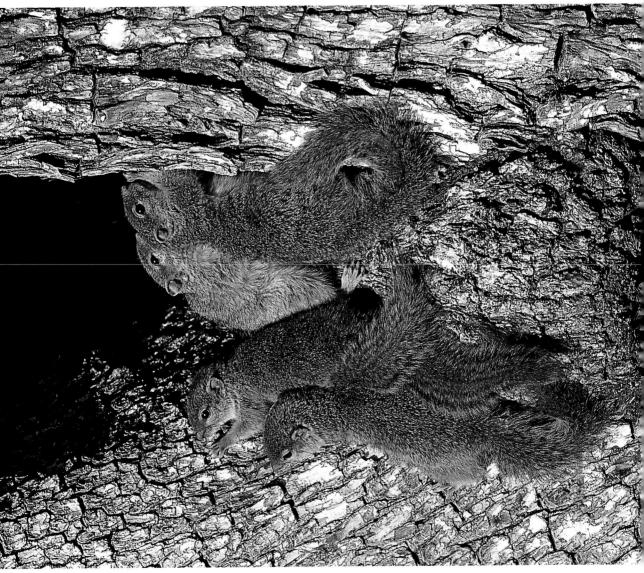

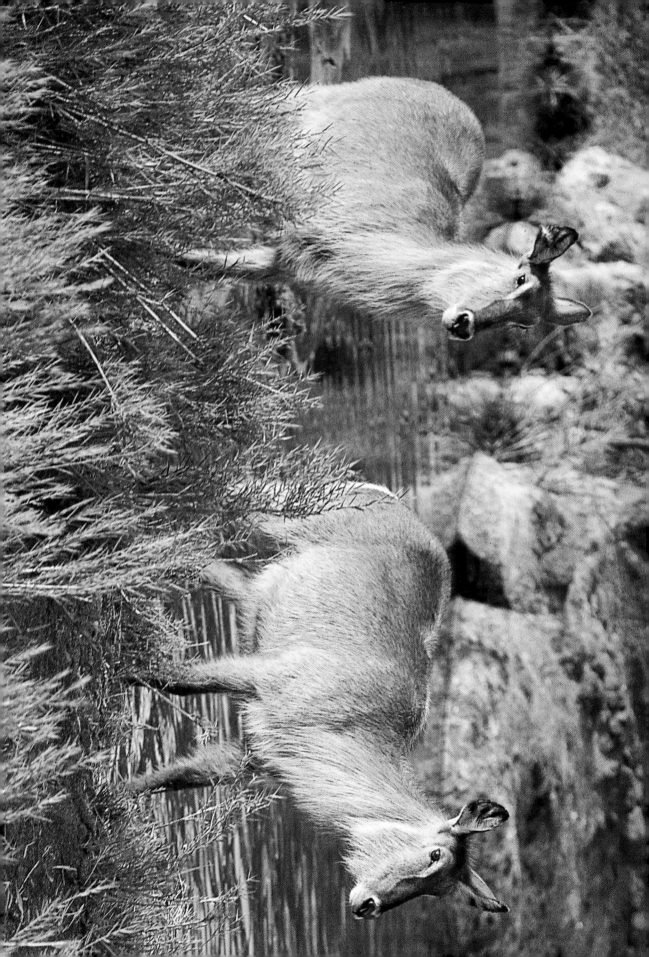

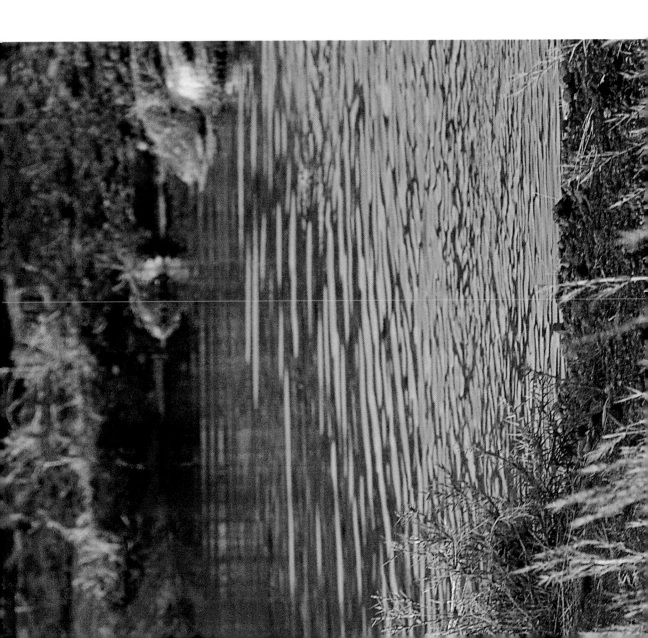

LEFT Two waterbuck cows cross a shallow area at the top of Kanniedood Dam near Shingwedzi.

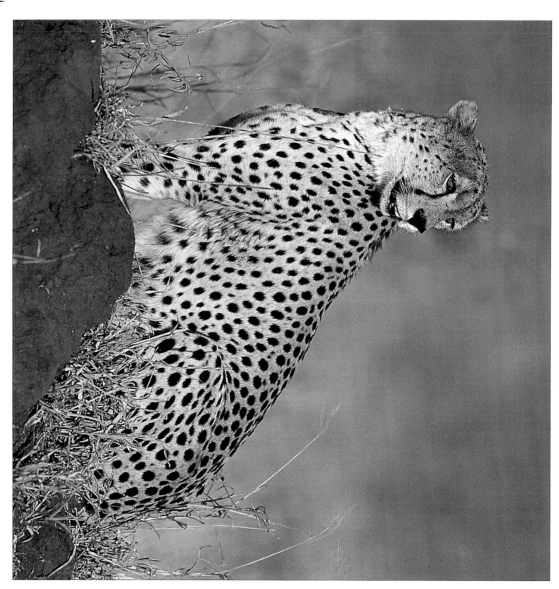

LEFT Cheetah occur only in moderate numbers in the Park and are most likely to be seen in the open savanna between Satara and Crocodile Bridge.

OPPOSITE Sunset in the Satara region: a cue for the big nocturnal predators – lion, leopard and hyaena – to become active.

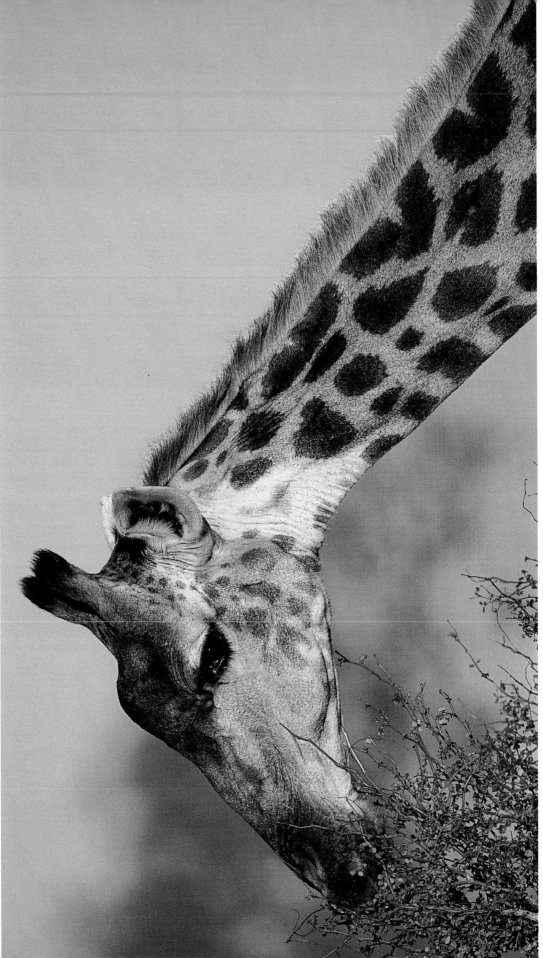

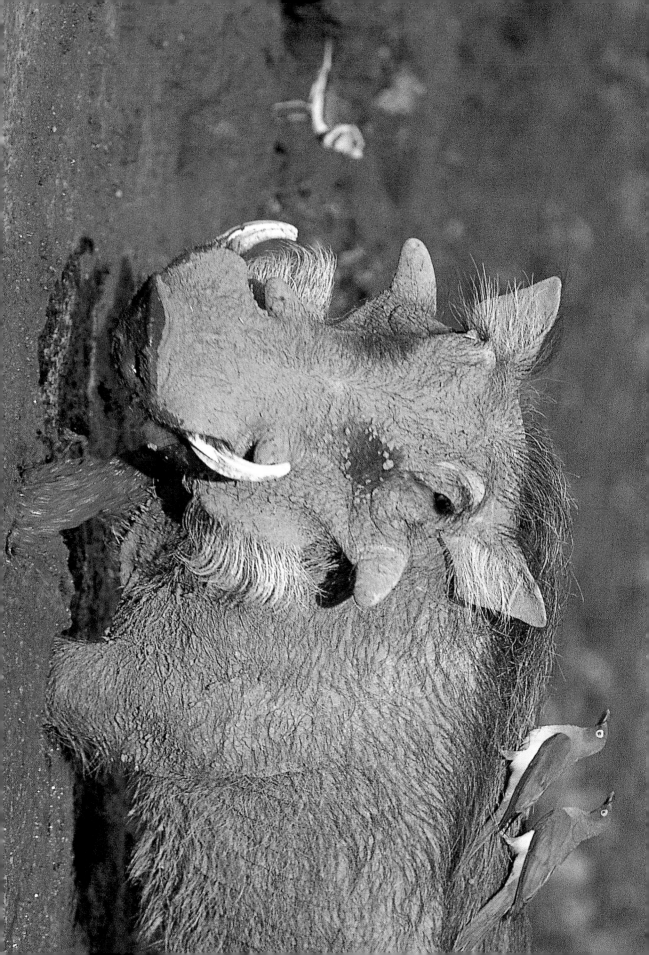

PREVIOUS PAGES, LEFT Steenbok are one of the few antelope species to form monogamous pairs. Here, a male is shown feeding on succulent new shoots.

PREVIOUS PAGES, RIGHT The Kruger National Park is home to about 5 000 giraffe. The area between the Sabie and Olifants rivers, in particular, has one of the highest densities of these animals in Africa.

LEFT A warthog enjoys a cooling mud wallow while two red-billed oxpeckers bring relief of another kind – by removing ticks and other parasites from the animal's hide.

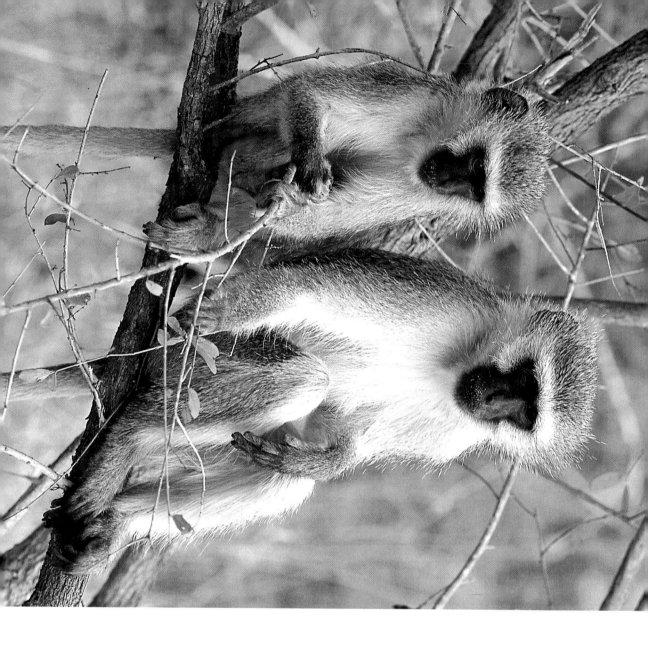

LEFT The mainly vegetarian vervet monkey
is known to supplement its diet by snatching
at passing insects or even raiding weavers'
nests for eggs.

OPPOSITE The Kruger National Park
supports about 150 troops of chacma baboon,
and individual troops may contain up to
100 animals.

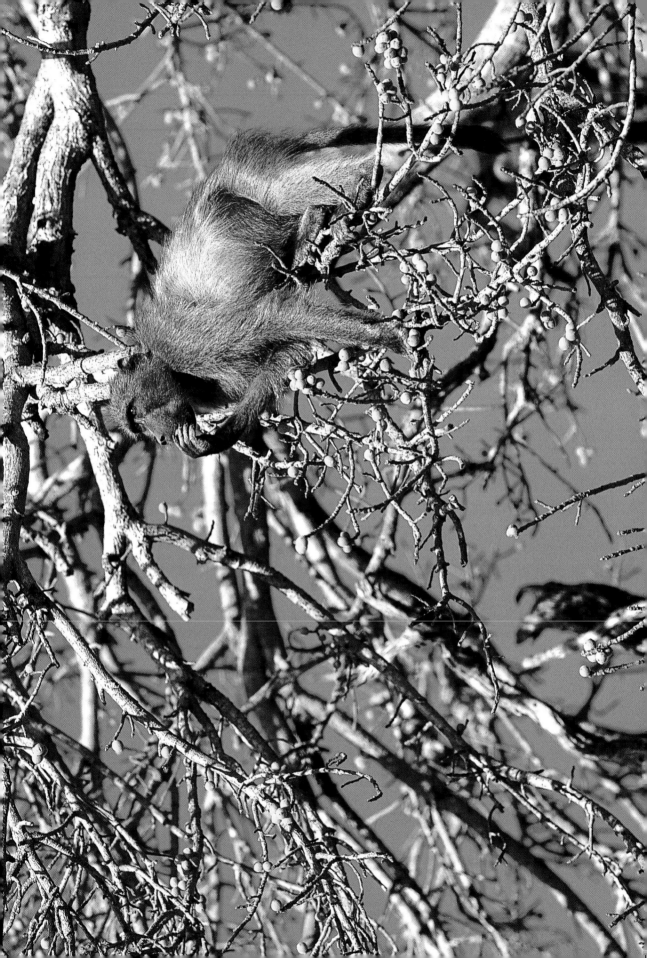

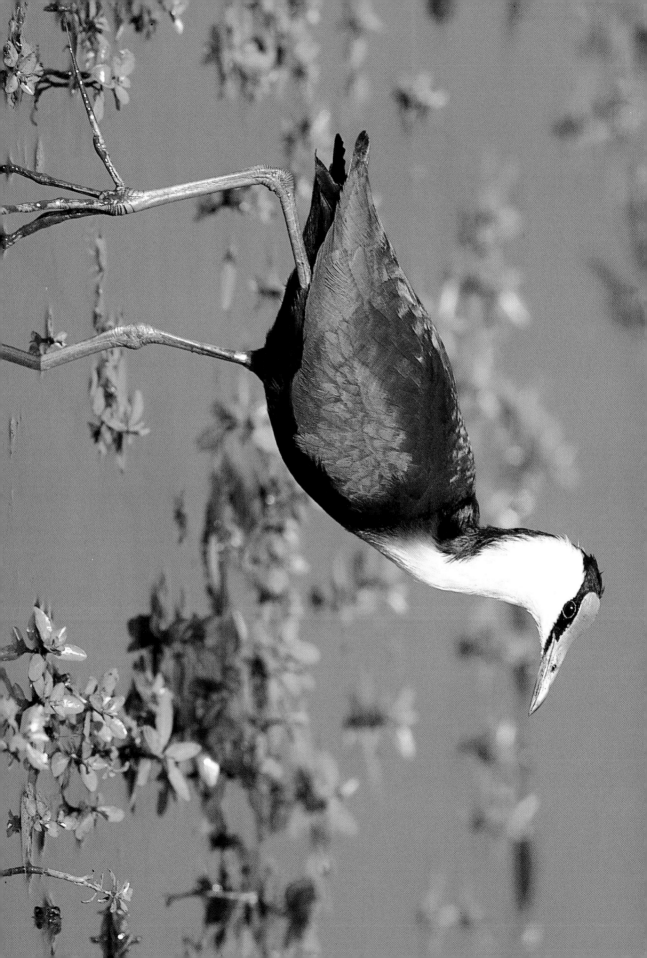

The numerous pans and dams in the Park offer good opportunities for viewing waterbirds. The African jacana (OPPOSITE) forages along shallow margins or among floating vegetation, its long toes allowing it to walk on the floating plants with ease. The red cormorant (LEFT) fishes in more open areas.

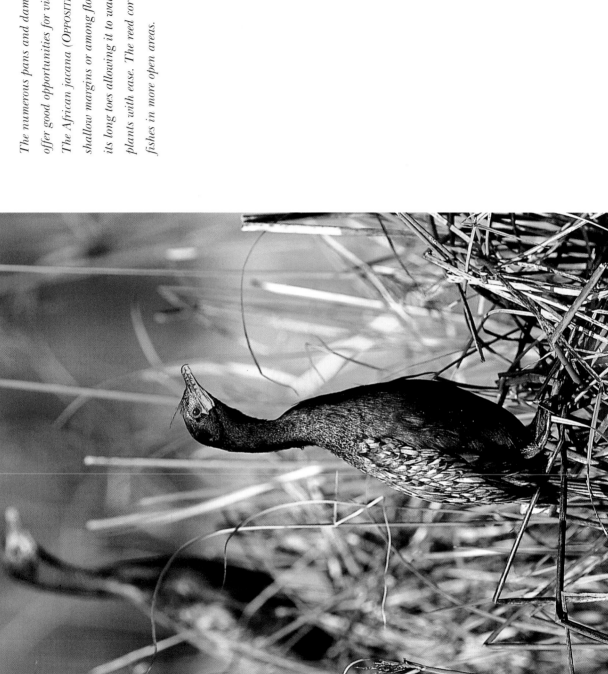

RIGHT *Cheetah experience intense competition from other predators, and often lose their captured prey to lion, leopard and hyaena. To reduce competition with these other predators, cheetah are diurnal, hunting by day.*

OVERLEAF, LEFT *Young chacma baboons engage in the rough and tumble of a play-fight, an important activity which helps them learn co-ordination skills.*

OVERLEAF, RIGHT *A young impala male cautiously sniffs the forehead of a mature ram.*

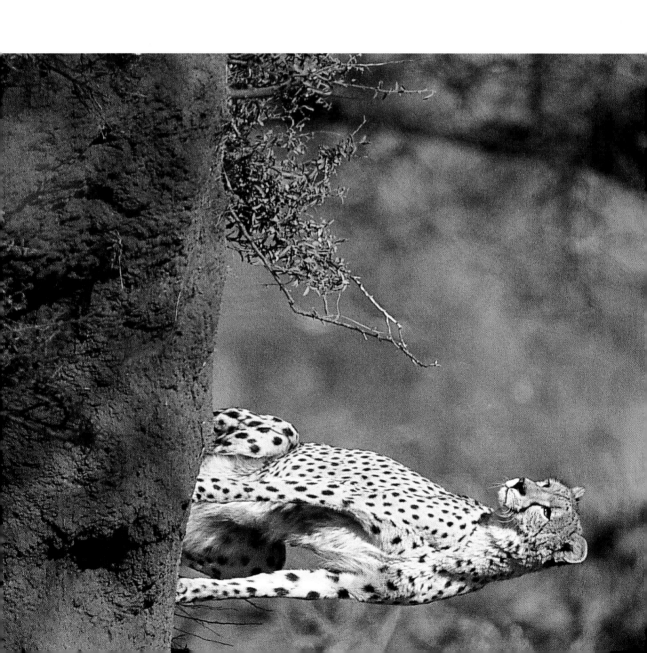

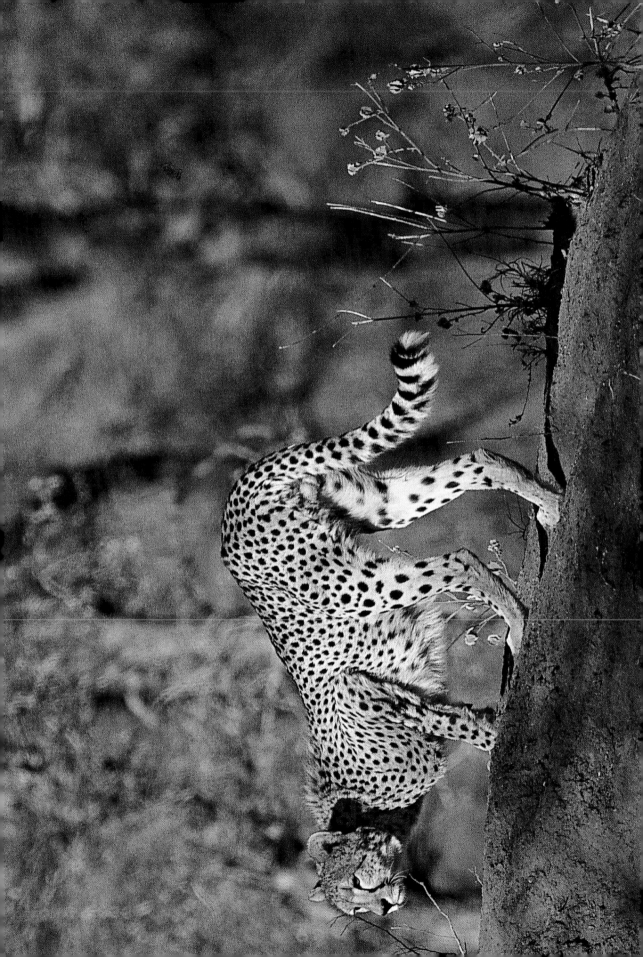

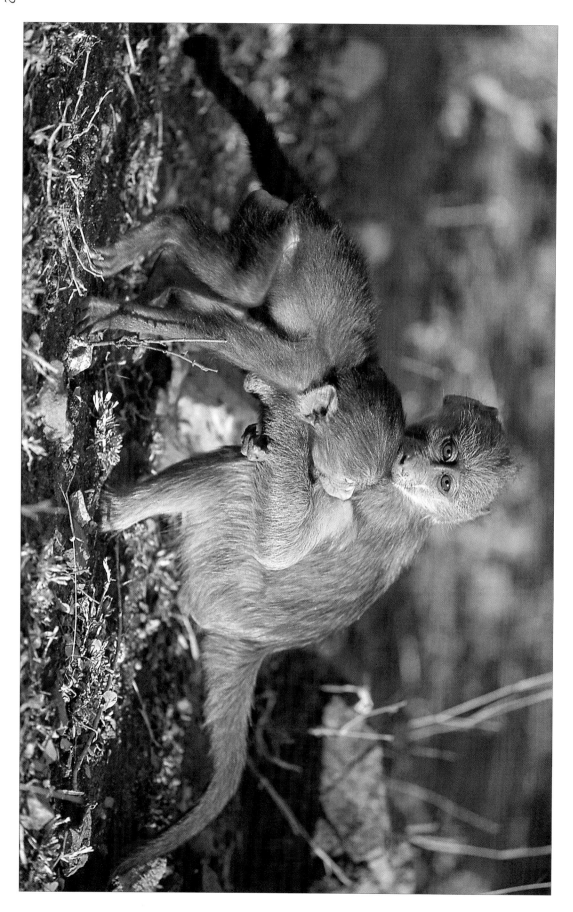

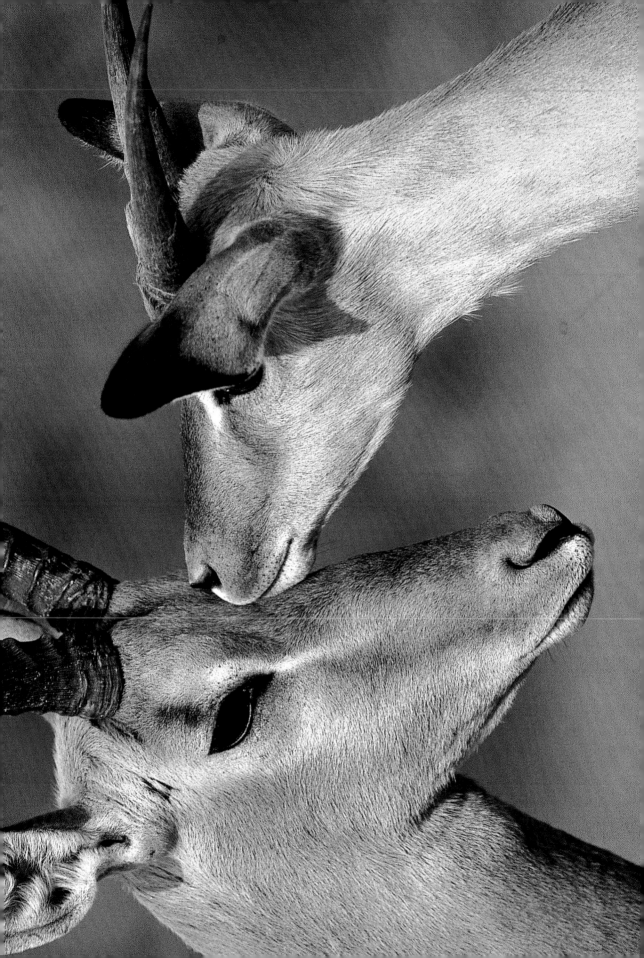

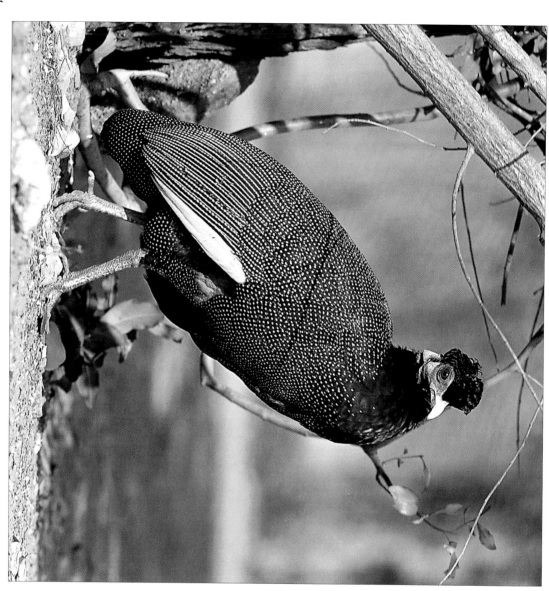

LEFT The crested guineafowl is a shy forest species which is confined mainly to the northern areas of the Park, and is occasionally seen at the Punda Maria campsite.

OPPOSITE The kori bustard is Africa's heaviest flying bird. During the breeding season in early summer the males fluff out their feathers in a strutting courtship display.

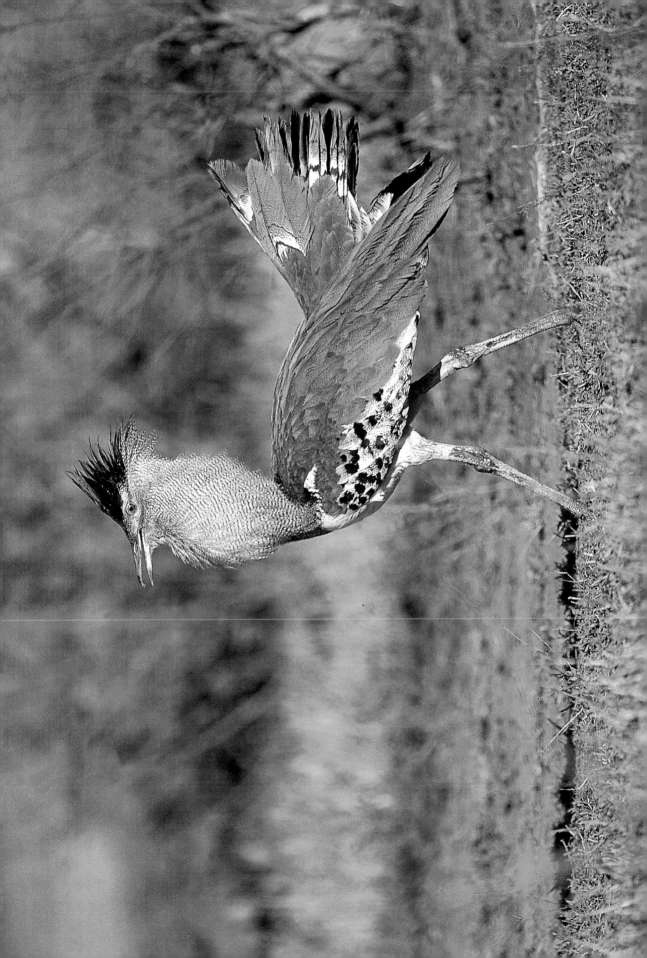

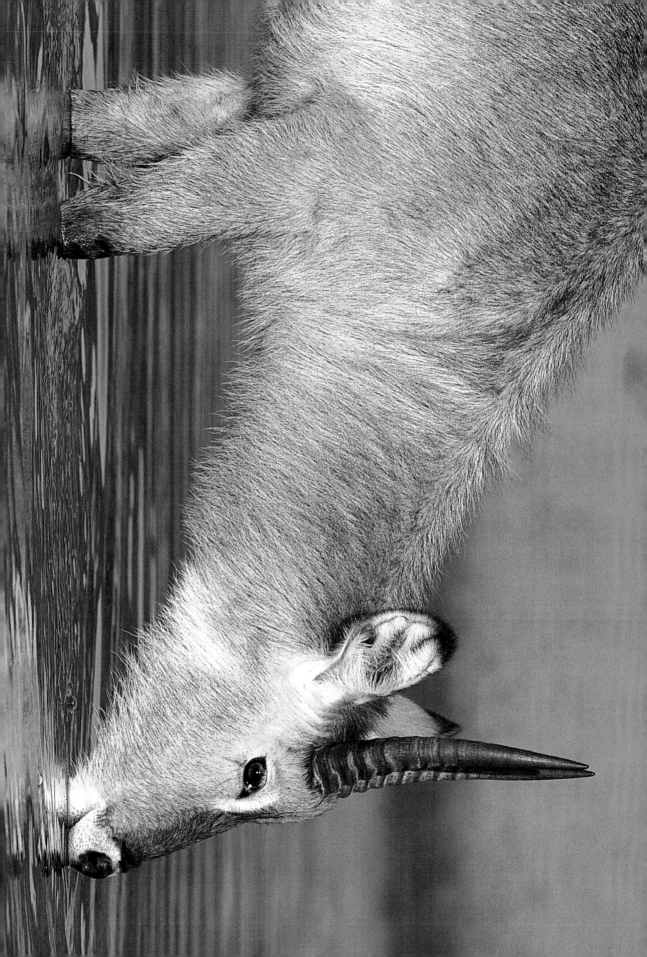

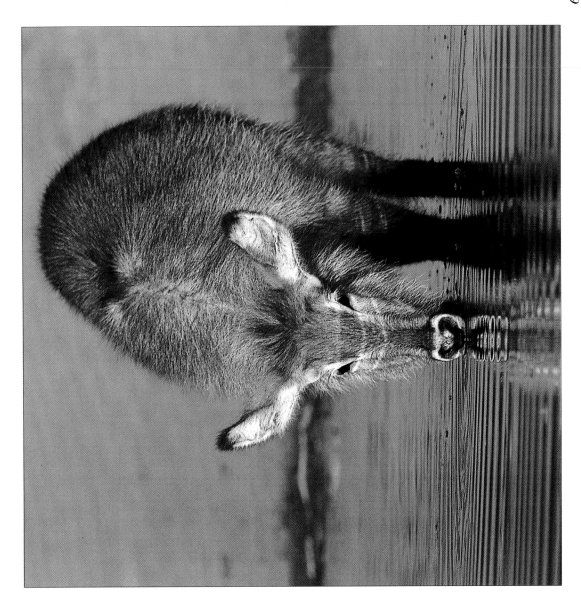

OPPOSITE AND RIGHT As suggested by its common name, the waterbuck is found only in areas associated with water. Since many of the best game-viewing roads follow river courses and drainage lines this animal is often encountered.

Since the introduction of night-time game drives, it has become possible for visitors to view many of the Park's nocturnal creatures. The bushpig (RIGHT) is a shy species confined to areas of dense vegetation. Civets (OPPOSITE) are small, cat-like predators weighing about 10 kilograms, and are regularly encountered on night drives.

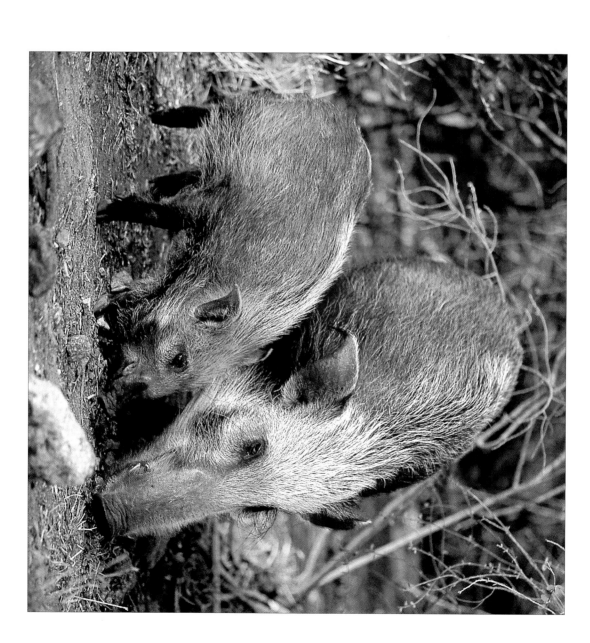

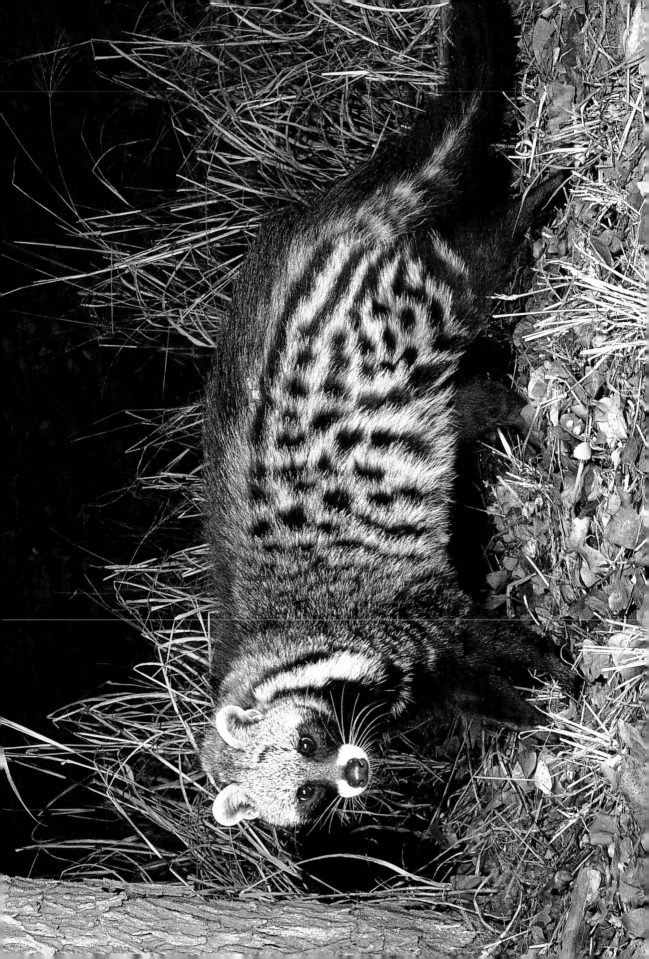

ABOVE AND RIGHT *The Kruger National Park is one of the endangered wild dog's last strongholds in Africa. These animals are great wanderers and may be encountered by a fortunate visitor almost anywhere in the Park. Wild dogs occasionally den in roadside culverts; the young pup shown above was photographed right next to the tourist road near Pretoriuskop.*

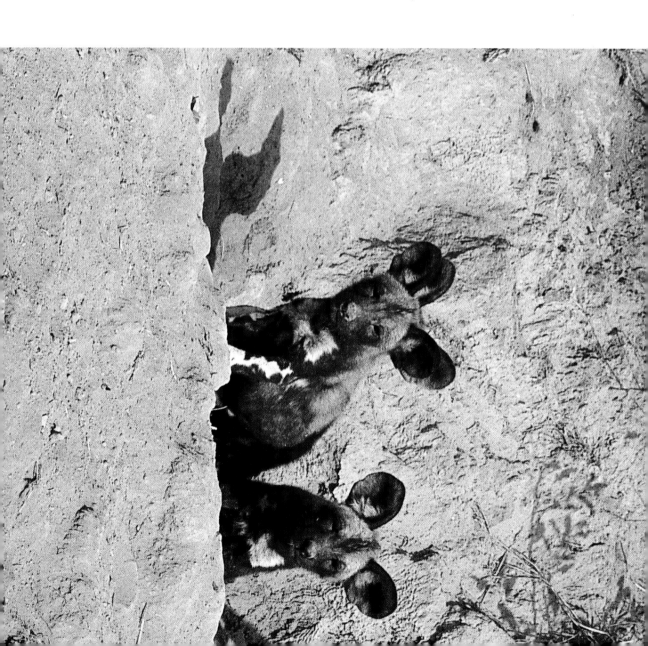

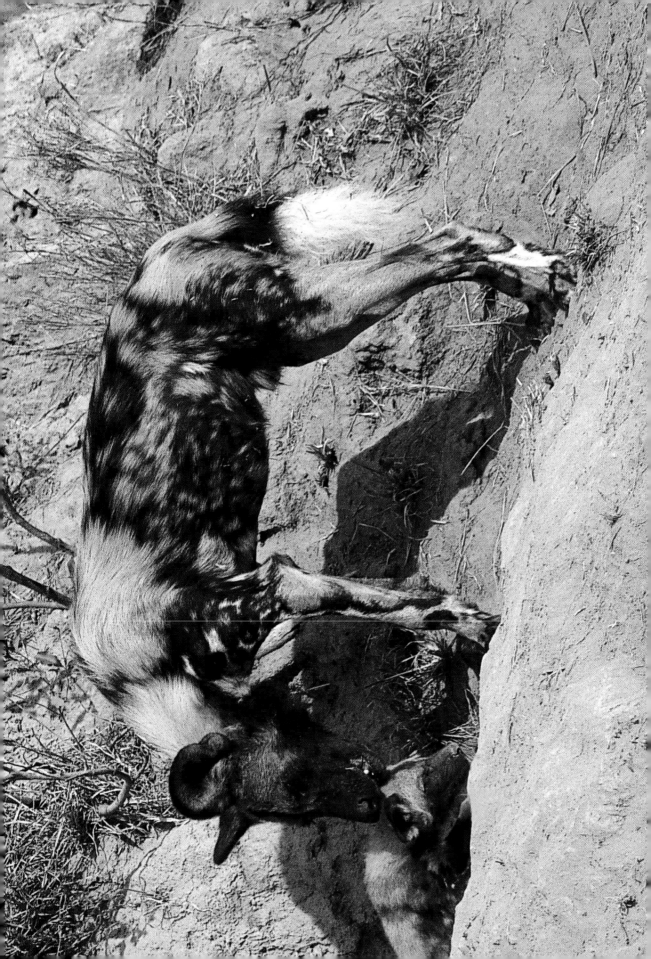

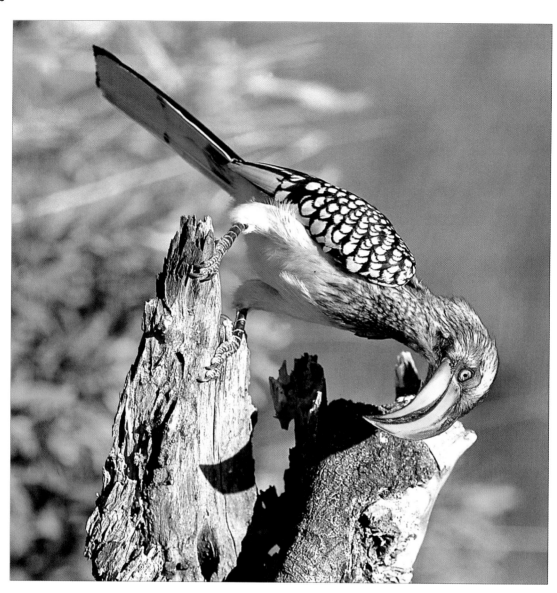

LEFT *Yellowbilled hornbills are frequently encountered in the Park's rest camps, where they have become quite tame.*
OPPOSITE *The strange gurgling coo of the green pigeon is a familiar sound of the Kruger bushveld.*

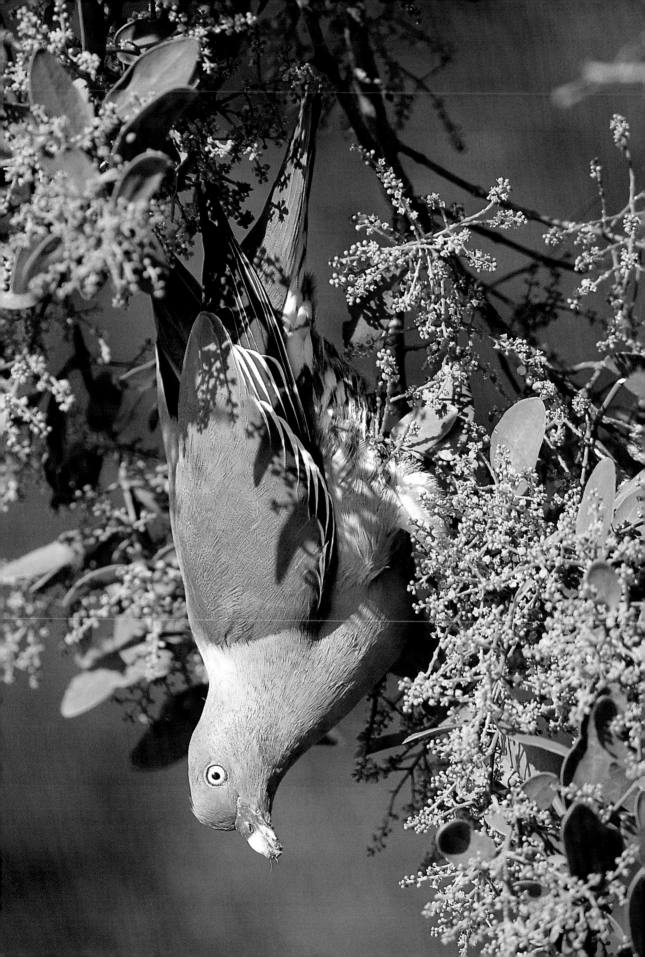

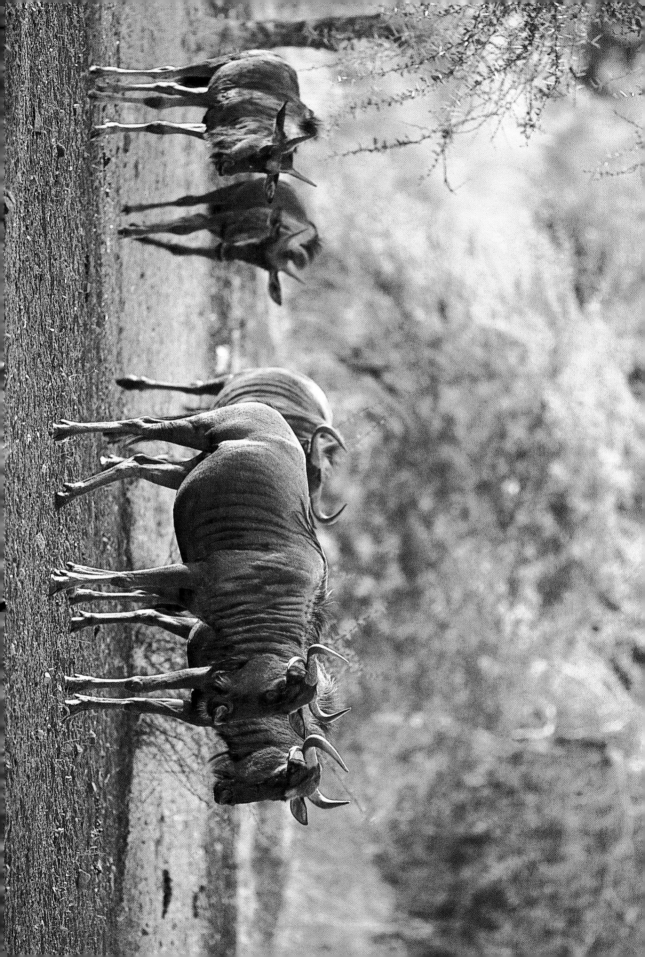

OPPOSITE *Blue wildebeest favour short grass areas and their numbers may actually decline following years of high rainfall when much of the Park is covered by tall grasses.*

LEFT *The white rhino population in Kruger has grown steadily over the years and now numbers more than 1 800.*

OVERLEAF *A pair of elephant stroll through the mopane vegetation of the far north. At present a population of just over 7 000 has been maintained by annual culling. However, with the proposed trans-frontier Park, which will incorporate adjacent protected areas in Zimbabwe and Mozambique and so create a huge conservation area, it is hoped that culling will not be necessary in the future.*

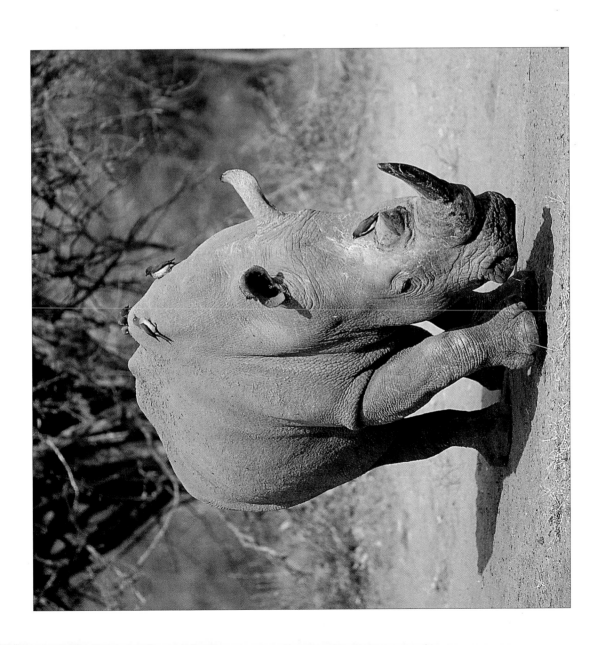

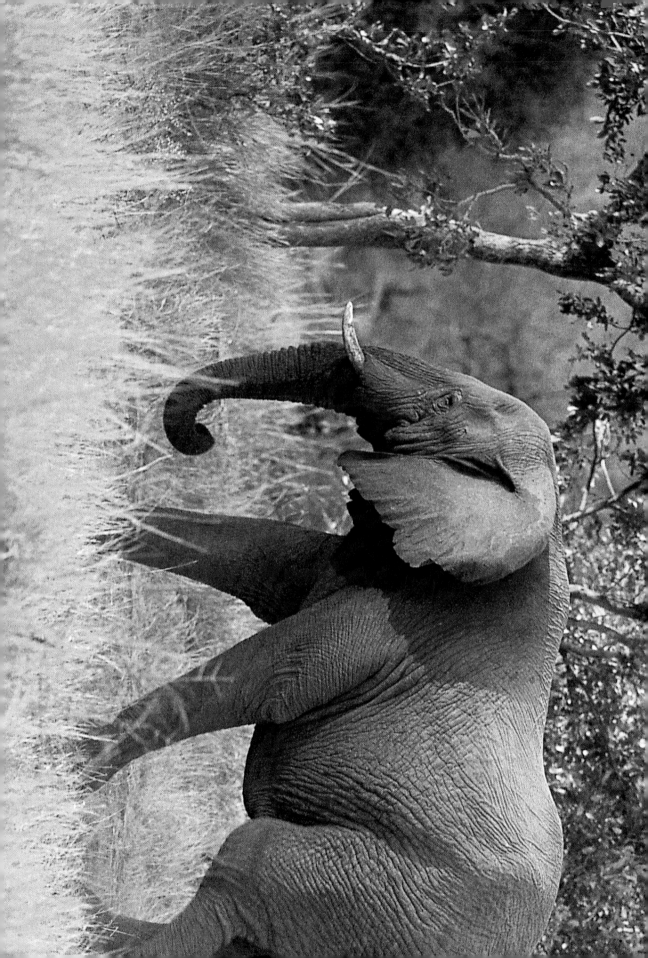

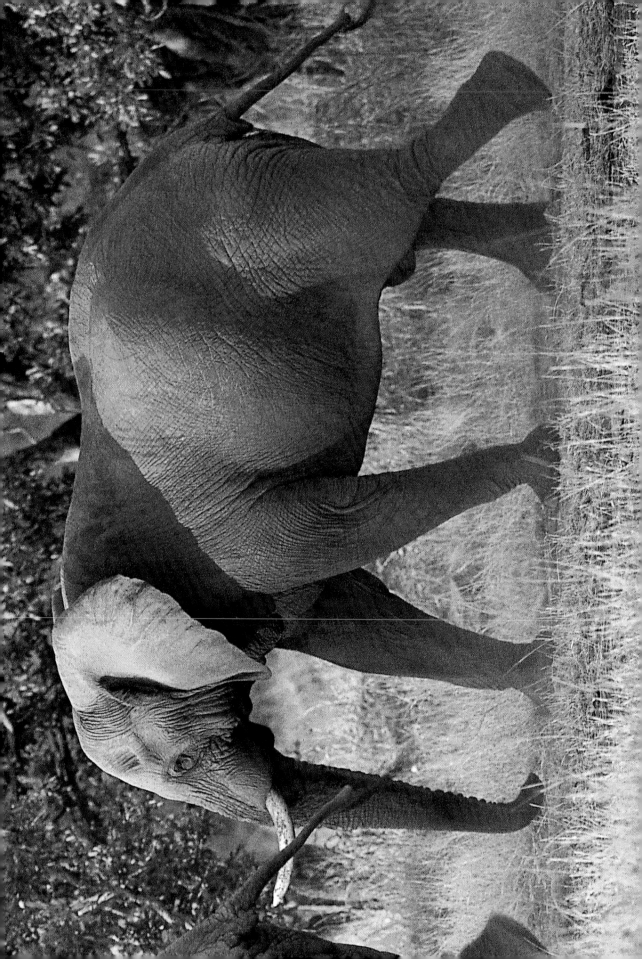

RIGHT A giraffe with its newborn calf.
OPPOSITE Magnificent specimens of baobab –
some up to 1 500 years old – may be seen in
the northern areas of the Park.
OVERLEAF Buffalo herds often number several
hundred animals, which make a rare spectacle
as they gather to drink at a waterhole.

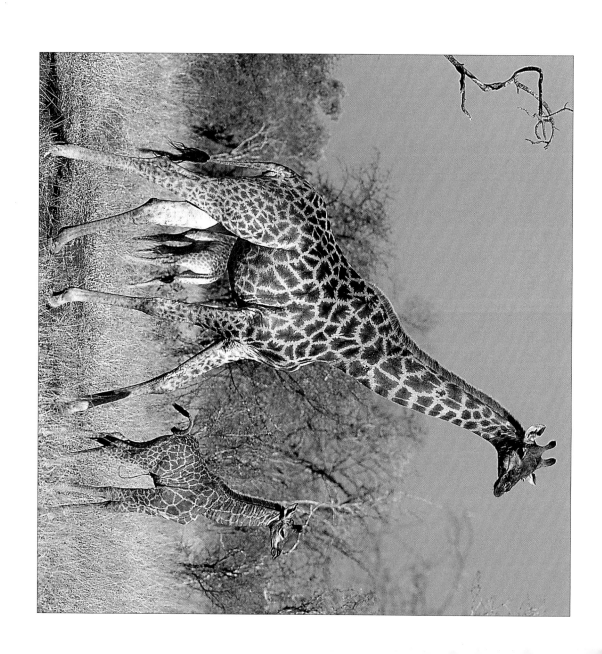

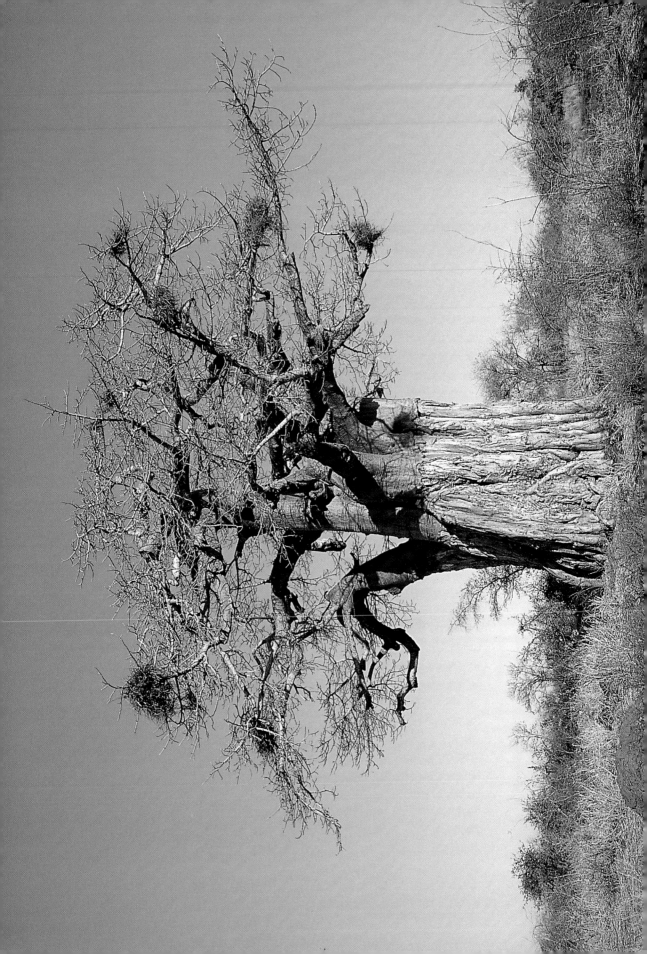

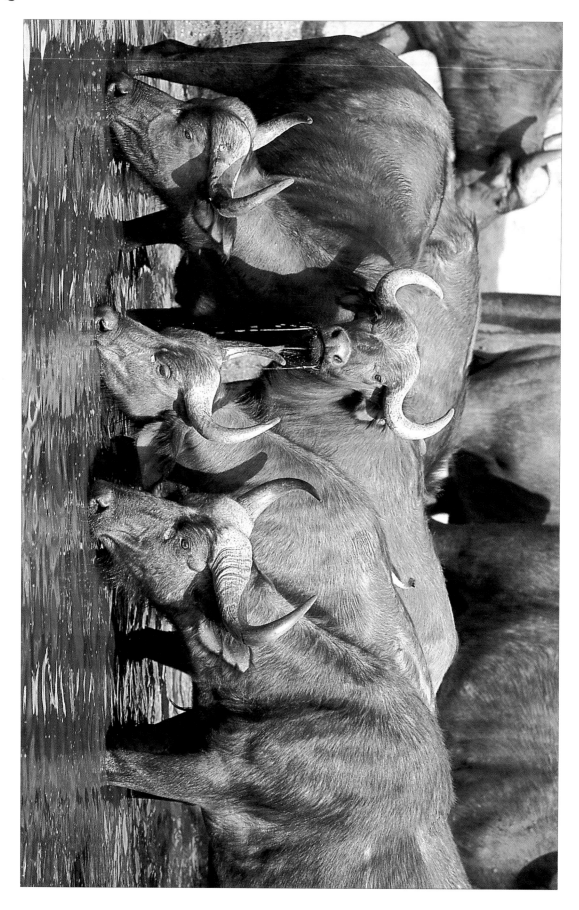

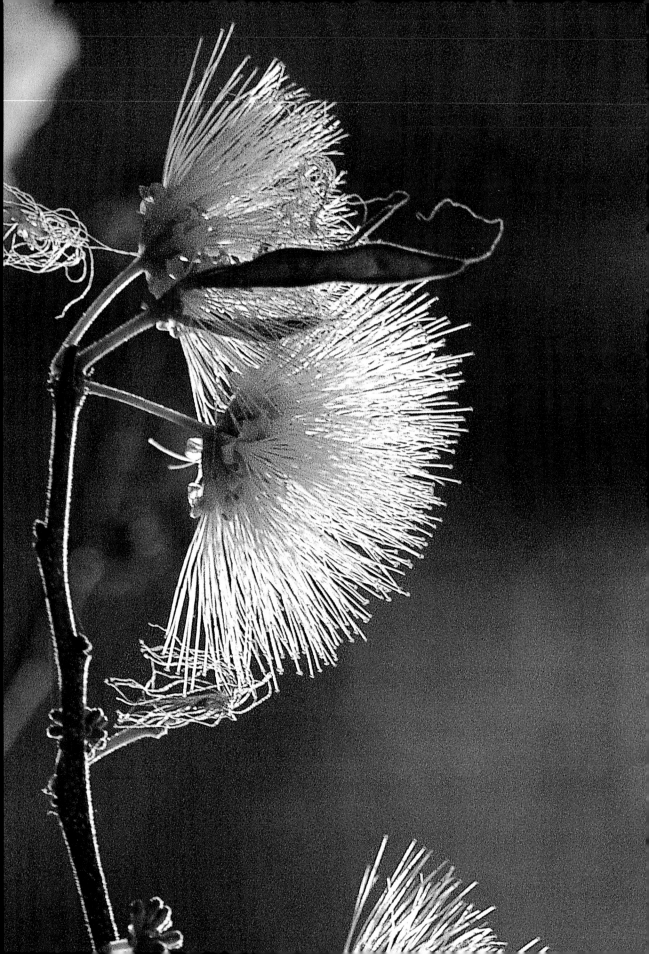